S0-ARD-503

RENNIE MACKINTOSH
INSPIRATIONS
IN EMBROIDERY

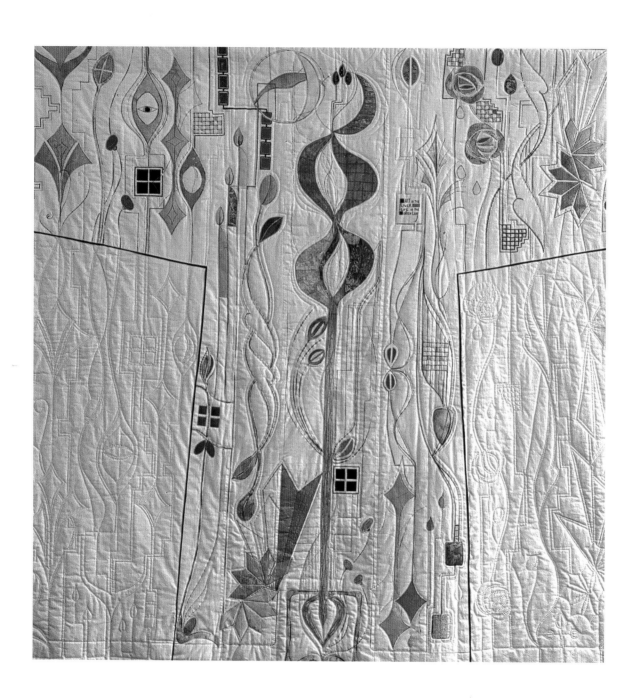

RENNIE MACKINTOSH
INSPIRATIONS
IN EMBROIDERY

DOROTHY WOOD

BT Batsford

Flagstaff Public Library
Flagstaff, Arizona

First Published 2004

Text © Dorothy Wood 2004

Volume © BT Batsford 2004

The right of Dorothy Wood to be identified as Author of this work has been asserted by her in accordance with the Copyright, Designs and Patents Act 1988.

Photography by Michael Wicks.

Images on pages 8, 22, 76 and 78 (far left) are © Hunterian Art Gallery, University of Glasgow, Mackintosh Collection

ISBN 07134 8857 3

A CIP catalogue record for this book is available from the British Library.

All rights reserved. No part of this publication may be reproduced in any form or by any means without permission from the publisher.

Printed in Malaysia

for the publishers

BT Batsford

Chrysalis Books Group

The Chrysalis Building

Bramley Road

London W10 6SP

www.batsford.com

A member of the Chrysalis Books Group

Page 2: Patchwork by Ena Dean. Photography © Mike Ireland 2003

746.44
W874R

CONTENTS

INTRODUCTION

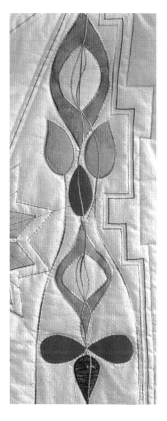

Detail of The Art of the Flower quilt seen opposite the title page. The kimono shape in this quilt is an attempt to capture the Japanese influence in Mackintosh's work. Appliqued motifs, in hand-dyed silk illustrate the 'harmony with nature' themes from Art Nouveau and Charles Rennie Mackintosh. (Piece by Ena Dean. Photograph © Mike Ireland 2003.)

■ Charles Rennie Mackintosh (1868–1928) was a perfectionist who spent his life mastering a diverse range of skills within the disciplines of architecture, decorative arts and painting. His work was unique and challenging not only because he refused to compromise his ideas, but also because he was part of an avant-garde decorative movement that centred on the Glasgow School of Art in Scotland. Known as the Glasgow Style, this movement brought together a talented group of people under the tutelage of the visionary principal, Francis Newbery (1853–1946). It was Newbery who introduced a range of crafts to the school including embroidery, metalwork, stained glass and woodcarving. This new emphasis to their work was central to the development of the Glasgow Style and although previously thought of as a poor relation to fine art, these craft skills were an integral part of their innovative designs.

The Glasgow Style, which reached its peak between 1895 and 1920, was positioned historically between the Arts and Crafts Movement and Art Nouveau at the end of the 19th century and Art Deco and Modernism at the beginning of the 20th century. It was one part of a spontaneous worldwide revolution in art that had strong links to the Viennese Secession Movement and Jugendstil in Germany. Occurring in a period when women were for the first time given the opportunity to further their education, the Glasgow Style had a distinctly feminine quality. The artists Margaret Macdonald (1864–1933), her sister Frances Macdonald (1873–1921), Jessie Newbery (1864–1948), Ann Macbeth (1875–1948), Margaret Gilmour (1860–1942), Mary Gilmour (1872–1938) and Jessie M King (1875–1949) played an important role in the development of the style and undoubtedly influenced its central figure, Charles Rennie Mackintosh. Because of the way classes were set up, students studying different courses came into contact with all kinds of students and design ideas passed freely between them.

Francis Newbery encouraged this exchange of ideas and collaboration, and because he had seen a similarity in the way they worked, introduced Charles Rennie Mackintosh and his good friend Herbert MacNair (1868–1955) to the Macdonald

sisters. This was the beginning of a prolific and successful career for Mackintosh. First as part of 'The Four' as they were known and later in partnership with Margaret Macdonald whom he married in 1900, Charles Rennie Mackintosh created a unique vocabulary of design and decoration, establishing an innovative style that would stand the test of time.

The aim of this book is to introduce embroiderers to the Glasgow Style and the work of its central figure, Charles Rennie Mackintosh. It looks not only at such instantly recognizable motifs as the Glasgow Rose and Mackintosh's distinctive designs based on squares and lattices but also at his less well-known textile designs and watercolours. Each chapter focuses on a different element of Mackintosh's work, showing how he was influenced by Margaret and Frances Macdonald and inspired by such diverse styles as Japonism and Celtic art.

This range of ideas will stimulate the imagination of any keen embroiderer. There are many motifs and samples that can be used to develop your own designs (see, for example, pages 26–27) and a selection of finished pieces to provide inspiration (as on page 62). As a workbook, too, it builds up from basic motifs for beginners to more complex work for advanced embroiderers. At the back of the book is a techniques section (see pages 104–120) that will help those new to embroidery to get started and a suppliers list (see page 125) allowing you to source all the materials used in the projects.

One of Mackintosh's strengths was his ability to give new life to old forms. The dilemma we all face when referring to his work is whether to stay strictly true to his designs or accept the challenge to move forward. Mackintosh's unique style has inspired countless imitations, some of questionable taste that have earned them the soubriquet 'Mockintosh'. Yet, if you are inspired by Charles Rennie Mackintosh and his contemporaries and knowledgeable about their work, use this inspirational resource to build up your embroidery and design skills and endeavour, in the process, to develop your own unmatched personal style.

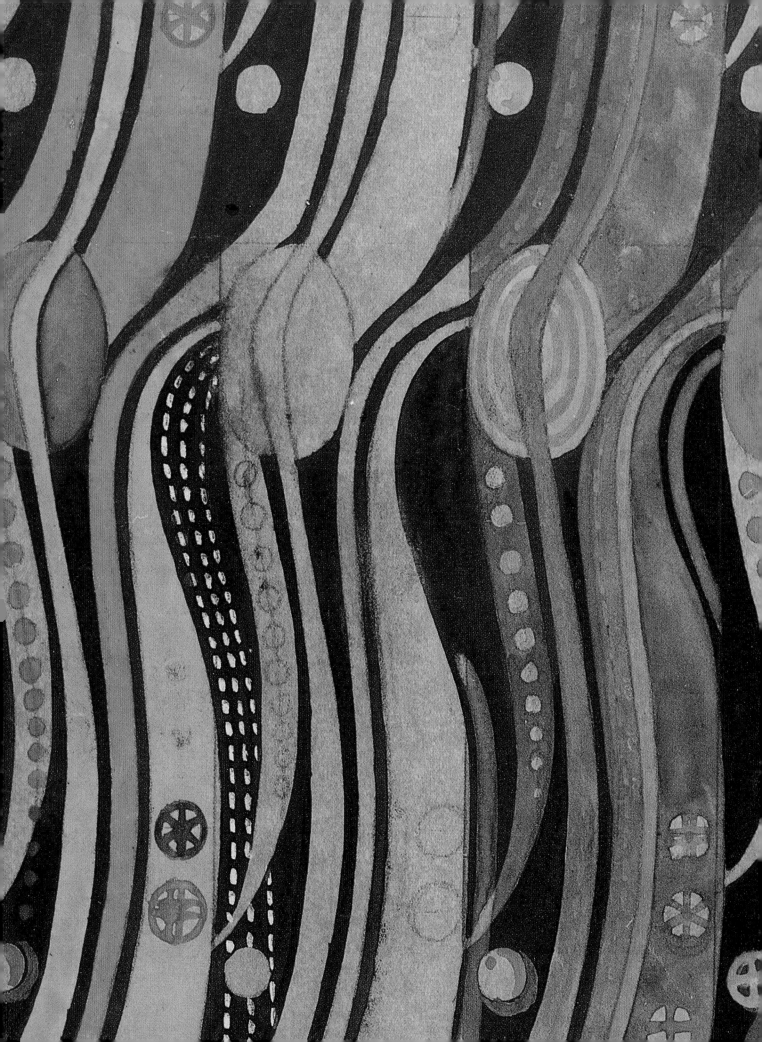

1 WHERE TO BEGIN?

There are few people who can begin with a blank piece of paper and produce a design for embroidery purely from their imagination. Most of us need to look at a source of inspiration and develop our ideas in stages so that they can be re-created in fabric and thread.

IDEAS AND INSPIRATION

In this stunningly simple design, Judith Brierley used a mix of techniques, such as patchwork, quilting, machine embroidery and goldwork to create her personal interpretation of the railings outside the Glasgow School of Art.

Inspiration for embroidery can come from anything or anywhere. If you take the time to look around, you will undoubtedly find interesting elements or images to record and develop into design ideas. But with so many possibilities to choose from, the real question is where to begin. Some people get inspiration from places they have been on holiday, bringing back sketches and photographs of the natural landscapes, urban scenery or other places of interest they have seen. Others look closer to home and find inspiration in the familiar view from their window or the flowers in their garden. By taking photographs, sketching ideas and writing notes, the information can be recorded and stored to be developed at a later date.

Another possible source of inspiration is to look at the work of other artists or art movements. Far from being the easy option, this can be a challenging task, but also

a valuable learning experience. Art students often analyse other painters' work, studying the colours and textures, composition and technique, and use this information to develop their own ideas and methods. Embroiderers can take this process one step further, developing the images, motifs, textures and colours that they find into fabric and thread.

The work of Charles Rennie Mackintosh is an ideal creative inspiration for embroiderers. He was a talented and prolific artist, craftsman and architect, so the volume of work available to study is prodigious. His stylized seed heads and rose motifs are instantly recognizable, as is the square motif known all round the world, but it is his less well-known watercolours and textile designs that embroiderers might find the most exciting source of ideas. As well as his imaginative symbolic paintings, he painted buildings in Vienna, beautifully detailed flowers in Walberswick, England and seaside ports in the south of France. Indeed, one of the most fascinating things about Charles Rennie Mackintosh is the variety of styles that he used over the years.

A wide brush was used to make simple rose and leaf motifs for this monoprint design by Beryl Smith. The motifs were outlined in machine embroidery with a fine metallic thread and the background embellished with French knots.

Charles Rennie Mackintosh himself took inspiration from his fellow artists and craftsmen. The rose that is so synonymous with the Mackintosh style was introduced by Jessie Newbery at the Glasgow School of Art as a simple motif for her embroidery students long before Charles Rennie Mackintosh used it in his work.

There are also obvious similarities in the work of Frances and Margaret Macdonald and Herbert MacNair who worked closely with Mackintosh; as a group they were known as 'The Four'.

The majority of Mackintosh's work – the buildings, the furniture and the artwork – is still there to be enjoyed and studied, most of it in and around Glasgow in Scotland. It is ideal if you have the

opportunity to see his work at first hand. Photographs, postcards and illustrations in books produce a fairly accurate representation but actually being there allows you to see the sheer volume of work and gives a much clearer idea of scale, the subtlety of the colours and the variety of materials used. Photography is not permitted in the majority of the Mackintosh buildings and museums, but sketching is freely allowed. Whatever your artistic ability, a sketch is always an invaluable way of recording what you see. There are so many little details that haven't been photographed and published that this provides the perfect opportunity to broaden your study and bring in original creative strands.

TRANSFERRING IDEAS TO PAPER

■ Whether you have the opportunity to see Mackintosh's work at first hand or are studying the many books available on the subject, the next stage is to transfer what you see to paper to develop ideas for embroidery. Experienced embroiderers will already have developed their own way of working, but for the novice a more structured approach is required that gives simple ways of transferring images to paper and developing them into practical ideas for embroidery. The stage-by-stage approach described here may seem basic, but it is simple enough to establish confidence and will inevitably lead to the development of a more personal, freer style. This chapter simply aims to give those new to design ways of developing their ideas and simple guidelines to take away some of the fear.

The temptation with embroidery is to begin straightaway with fabric and threads. This is fine if you have a specific technique or project in mind, but for a more creative approach it is preferable to develop ideas over several days or weeks and let the design for embroidery emerge from your research. By resisting the temptation to go with the first idea that comes to mind and doing a little preparatory work, you will be amazed at the designs and inspiration that can result.

The main stumbling block for the majority of those designing for the first time is a lack of confidence in their drawing skills. For many, the process of putting pencil to paper is a major obstacle, but it is a skill just like any other and can be improved with practice and determination. If you are interested in using accurate translations of designs while developing your sketching skills, there are other methods that can be tried. With traced images, photocopies or a computer scanner, it is easy to get accurate information on paper ready to develop into a design. This is particularly important in the initial inspiration stages of designing from a creative source such

Opposite: Silk /viscose velvet was dyed deep pink and painted on the reverse side with Fibre Etch to create devoré rose motifs. Adhesive water soluble fabric added stability to the fabric for the simple machine embroidery spirals. Work by Dorothy Wood.

as the work of Charles Rennie Mackintosh. Because his style is so distinctive, the images need to keep the original proportions or the piece will lose the particular character of Charles Rennie Mackintosh's work. For more advanced textile work, this is less of a concern, as an initial design can be simplified and abstracted to such a degree that the inspiration source is no longer obvious.

Stage 1

Begin by collecting as much visual information as you can about Charles Rennie Mackintosh and the Glasgow Style. Use the bibliography (see page 121) to find specific books, or alternatively look in your local library, remembering that you can always order individual books from other branches. If you can, use the Mackintosh resources in Glasgow or in a museum such as the V&A in London to see his work for yourself, make rough sketches and take notes. Buy postcards or photocopy some of the images from your books and arrange your collection on a pinboard or large sheet of paper. As you become more familiar with the work of Charles Rennie Mackintosh and his contemporaries and focus on the collected images, you will begin to find motifs, colours and shapes that you like in particular. You can add to the collection as your research develops, adding swatches of fabric and thread in colours drawn from the images.

Stage 2

The next stage is to draw out one or more of the simple motifs and shapes that you have collected. When working from books or postcards the motif is often quite small, so if necessary scan the image to use on the computer or use a photocopier to enlarge it to a more suitable size. If you don't have the confidence to sketch the enlarged image, use tracing paper and then transfer it to paper.

This motif (stage 2) is taken from the lampshade in the drawing room at Hill House in Helensburgh. The motif from the lampshade has been turned upside down and then developed into a simple design (stage 3).

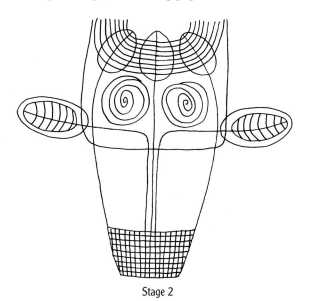

Stage 2

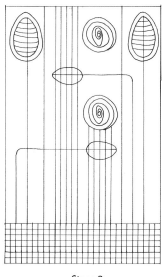

Stage 3

Stage 3

Use the enlarged images as inspiration and begin to make sketches using aspects of the original in different ways. This is not necessarily a quick process, but the more you practise, the easier it will become and you will soon find that drawing out your ideas in this way is indispensable to the design process. Then choose the sketch that you would like to develop further. Look at it critically and decide if it needs to be altered in any way. In the case shown here, the original sketch was too condensed and didn't have the characteristic elegance of Charles Rennie Mackintosh's work; lengthening the vertical lines improved the proportions and helped achieve the right balance.

Making several copies of the one design is a quick way to try out a range of colourways.

Stage 4

The next stage is to introduce colour. Use crayons, ink, paint or torn tissue paper to create coloured images. If you are not a confident artist, draw or trace your design in black ink and make several copies. This may seem too much like painting by numbers, but it does let you try out a range of colourways quickly. To begin with, use the colours in the original image and then try out other colour schemes. Creating a stunning artwork is not the point of this exercise – it's simply a way of developing your sketches so that an idea may eventually emerge that inspires you to re-create your design in fabric.

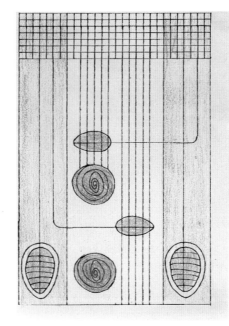

Stage 5

Choose the coloured image that you like best from your selection to try out some fabric samples.

Collect fabric swatches, threads and any other bits and pieces that match the coloured design.

Stage 6

Decide on some embroidery techniques that you feel will suit the chosen design. Don't go straight for the obvious and try the same motif in several different fabrics and colour schemes using both hand and machine embroidery. The way you develop the design into fabric will depend on your experience as a textile artist. You may have a wealth of different techniques that you are familiar with, but if not, use the techniques section (see pages 104–120) as the inspiration to develop your design. Note that at this stage it may be necessary to alter the size of the image to suit the technique.

Try out a range of techniques using the same design to develop your ideas.

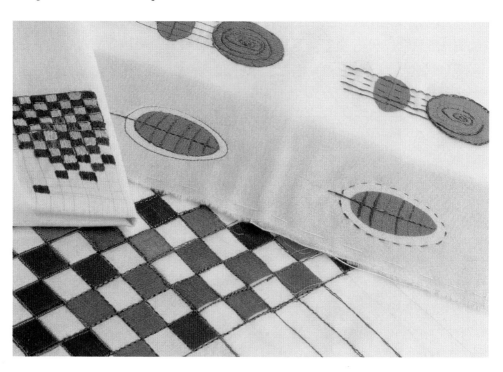

COLLECTING YOUR IDEAS TOGETHER

■ Arrange your stitch samples, drawings and coloured sketches with some of the images from the initial collection. At this stage, it may be obvious that your ideas are developing in a particular direction and you might want to continue in this vein, but this can also just be a starting point. There is no pressure to create a finished piece and any development work can be stored for future reference.

When researching a subject for embroidery it is a good idea to keep sketches, fabric samples and notes together. Gathering the separate pieces in one place helps to consolidate ideas and enables you to see how your work has progressed over time.

Sketching in pencil is not the only way of recording images and developing ideas. If unsure, there is a temptation to constantly rub out, losing the spontaneity and freshness of the design. Try working in pen instead and try colours other than black. Coloured ink pens on a variety of coloured papers or white ink on black paper can produce a completely different effect. If you prefer to work neatly and on a small scale, try using a large paintbrush on oversize sheets of paper and create an image that is the opposite of your usual style. You may find that working in this way frees you from any inbuilt constraints and produces unexpected patterns and images for embroidery.

Paper is another useful material for creating design ideas; tissue papers especially give the design an immediate textile association. Paper can be scrunched, folded, cut, layered and glued to create unusual inspirational effects.

The important thing is to find a way of recording and developing ideas that works for you. This background research need not be a masterpiece. It is simply a means to an end – an essential part of the creative process.

How you store your ideas is very much a matter of personal preference. Some people work confidently in a sketchbook, sticking fabric samples in alongside their sketches until it is literally bursting at the seams. Others work on sheets of paper and then bind them together at a later date. Whatever method you choose, it has to be one you are comfortable with so that the collection process is easy. The reward is a valuable visual resource full of inspiring ideas that can be used to create exciting textile pieces.

TRYING DIFFERENT MEDIA

Beryl Smith has been inspired by the work of Charles Rennie Mackintosh for several years and has created a series of workbooks, each with a different cover design, to record her work.

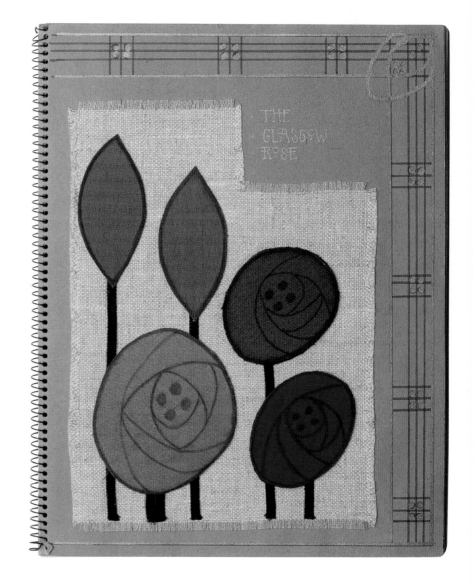

Imogen Aust used a large paint brush and bold colours to develop designs from one of Charles Rennie Mackintosh's textile designs.

Imogen Aust used bold acrylic paints to develop some of Mackintosh's textile designs. Working in such a free way led to a series of embroideries worked on handmade felt.

Fabric and textile samples are an essential part of the ideas book, creating a handy reference for the incorporated techniques, threads and colours used in the design ideas. Although most of us have a broader knowledge of textile techniques than we ever actually employ, it can be a useful exercise to concentrate on one in particular and, in a sense, relearn the technique. Quilting and appliqué are traditional techniques that can be developed in different ways and the boundaries of these techniques can be stretched to create unusual effects. If you enjoy stitching by machine, try the new water-soluble fabrics that are so easy to use. Heavyweight fabric is strong enough to make freestanding embroidery or containers and the self-adhesive version is ideal for bonding fabrics and thread onto the design prior to stitching.

TEXTILE TECHNIQUES

Trying a new skill such as batik can take your ideas in a new and exciting direction (work by Beryl Smith).

Incorporating new methods and materials can also be a strong source of ideas. Learn a new skill, such as making felt or paper. Try batik, silk painting and discharge cotton or create interesting coloured backgrounds by space dyeing. Use transfer paints, stencilling, monoprinting or stamping to create designs on fabric, or try new products such as Fibre Etch to make your own devoré velvet.

Many people nowadays have a computer at home, but not all of them realize its design potential. Computers can be used to create coloured and patterned background papers for your ideas book. They are ideal for making multiple copies of the same motif or design and can be used to develop simple designs into more exciting artistic images, creating possibilities and ideas for more advanced textile work. Certain programs can change a colour photograph into a crayon drawing or even a black-and-white sketch and the resulting image can then be developed into a design for embroidery.

USING A COMPUTER TO DEVELOP DESIGN IDEAS

As long as you have a scanner or digital camera to transfer the image to the computer, the possibilities are endless. Once the initial colourway has been filled in,

it is quick and easy to change colour schemes and alter the image in varied ways. You will be amazed at the stunning pieces of art that you can create. Every photo program is different and you will need to experiment on your own computer.

The following tips will help you get started:

- Scan the image in colour even if it is a black-and-white drawing. This allows you to use the paint/draw tools and fill areas in colour in the photo program.
- The black-and-white image should open automatically in the photo program and can be coloured using the paint-tool option.
- Use bucket fill to colour each area of the design. You can change the depth of colour by clicking the bucket-fill tool on the same area again.
- Paint tools such as crayon, paintbrush, airbrush etc. give different effects. When working with these tools, you can change the shape and size of the mark that is being made on the paper.
- Try altering the transparency or softening the edge of the mark to give different effects.
- Use the special effects to change the colourway of the design and the crop tool to select areas of the design for further development.

Crop into an area of a computer image to create a design for a cushion panel.

As with anything new, the important thing is to try different ideas and explore everything that your program has to offer. If you have a cloning tool, the basic coloured image can be turned into an inspiring abstract design. This tool allows you to 'draw' areas of the image elsewhere on the design. It is fun to use and the results can be quite dramatic. By altering the size, shape and transparency of the cloned areas innovative abstract designs can be created in a matter of minutes.

This design was developed from the initial sketch on page 14. The scanned image was coloured using the paint tools and then abstracted using the cloning tool.

MOVING ON

■ The best way to develop creatively as a textile artist and eventually establish your own particular style is to get involved with an in-depth study. While an ideal topic, the sheer volume of work produced by Charles Rennie Mackintosh can be overwhelming and any study potentially fragmented and superficial. It is a good idea, therefore, to focus on one area of his work at a time and eventually narrow that overview down to a particular aspect that excites and inspires you.

To that end, the following chapters are each devoted to a particular aspect of Charles Rennie Mackintosh's work. The next one introduces the familiar Glasgow Rose, which is an ideal motif for trying out different techniques, and chapters follow on his distinctive use of squares, seed heads and sensuous ladies. Other chapters concentrate on the repeat patterns of his textile designs and the beautiful textures, shapes and colours in his watercolours. Use the information in the chapters as a basis for your own research. Make your own collection of sketches, notes and photographs or postcards and use these a starting point for a new creative journey to uncover the design potential of the style of Charles Rennie Mackintosh.

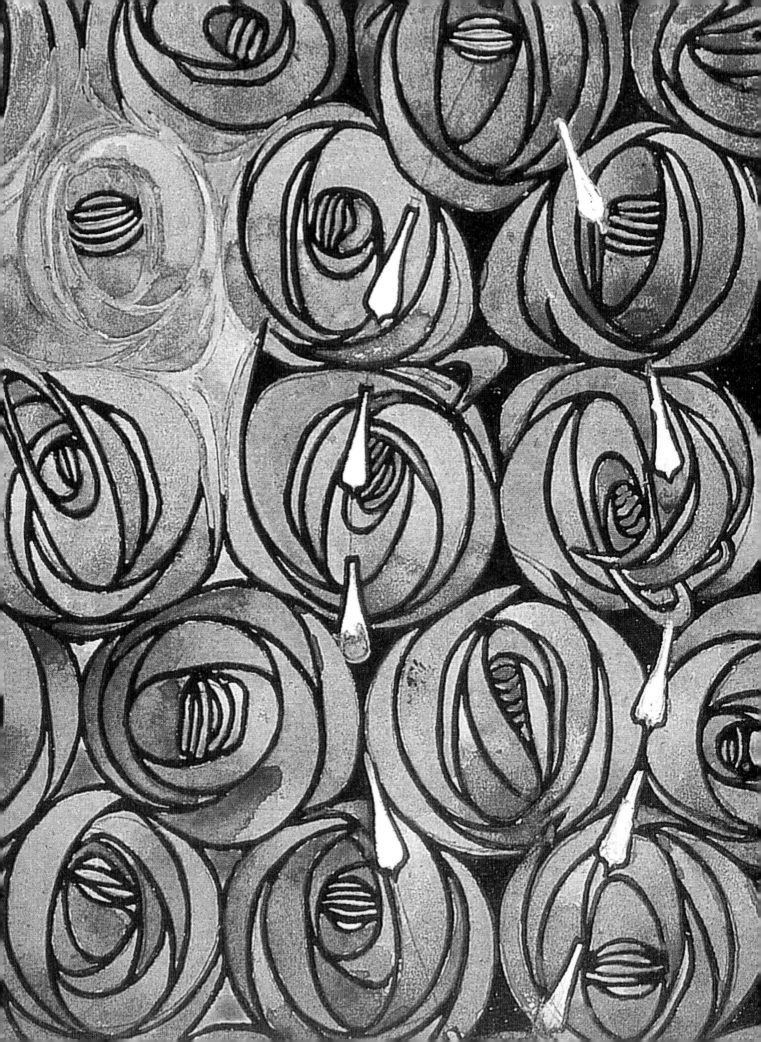

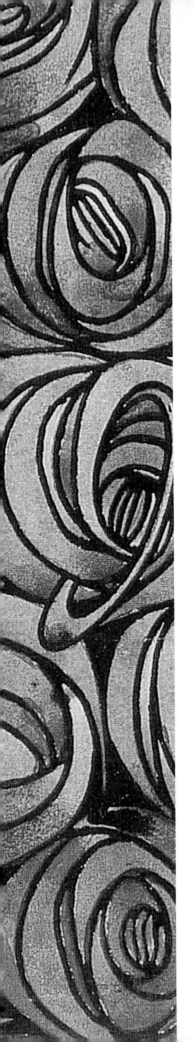

2

THE GLASGOW ROSE

■ The rose is one of the most recognizable elements of the Glasgow Style. Between 1875 and 1920 it was an extremely popular decorative motif in a range of crafts from metalwork to furniture and became known all around the world through work displayed at international exhibitions in Glasgow and Vienna.

The Rose Boudoir, created by Charles Rennie Mackintosh and Margaret Macdonald for the International Exhibition of Modern Art in Turin in 1902, showed how Mackintosh used the rose motif as a unifying element in his early interiors. This holistic approach, with repeating patterns, motifs and colours recurring in all elements of the furnishings, was much admired by the Viennese who loved his experimental and creative artistry.

The choice of the rose, a traditional emblem of creativity and love, as an icon for decorative art was appropriate at the time because the Glasgow Style was predominantly feminine. Although used on a wide range of crafts, its introduction at the Glasgow School of Art is widely attributed to Jessie Newbery. A keen gardener, she sketched stylized rose motifs to use in her own embroidery and introduced the simple appliqué technique in her embroidery classes. The simply cut circle of pink linen with satin-stitch lines indicating the folds of the rose petals was a popular motif with her embroidery students and the stylized rose was quickly taken up by other students to use in other media. Margaret Macdonald used the rose extensively in her paintings, gesso panels and beaten metalwork and there is no doubt that this work inspired Mackintosh to use it in his own designs. He offset the feminine form of the rose with the more masculine structure of the square and used tertiary colours such as green, rose, grey blue and mauve to create distinctive rose designs that were thought at the time to be radical and cutting edge.

Charles Rennie Mackintosh adapted the design of the rose to suit a wide range of craft techniques, including stained glass and stencilling. Mackintosh's architectural training influenced his craftwork and his rose designs for stained glass are characteristically bold, with strong colours and heavy black lines a predominant feature. In contrast, the stencilling has more muted colours and softer shapes. Mackintosh, along with other artists at the time, adapted the rose motif to suit whatever medium he was working in and so there are literally hundreds of versions of the Glasgow Rose.

Opposite, below: This design (by Janet Adams) uses a combination of trapunto quilting and shadow quilting to subtle effect. Dyed silk 'tops' were used to pad behind a sheer fabric to create the coloured areas.

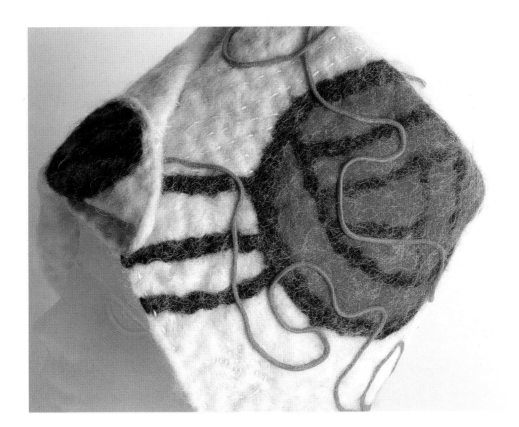

Beryl Smith was inspired by Rennie Mackintosh's stained glass rose motif when designing this hat in handmade felt.

The huge resource of rose motifs in the Glasgow Style is an ideal starting point for trying out a wide range of techniques in embroidery. The shapes and lines of the different rose motifs lend themselves to particular techniques and can be used to build up a library of embroidery samples for future reference.

USING THE ROSE MOTIF IN EMBROIDERY

Trace the motifs from the templates (on page 26) and enlarge them to a suitable size for the particular technique. You can simply use the template samples of hand embroidery, quilting, machine embroidery and appliqué or develop more advanced designs by repeating motifs or designing your own roses in a similar style. Think about how Charles Rennie Mackintosh used lines, grids and squares to balance the feminine aspect of the motif and create your own personal interpretations.

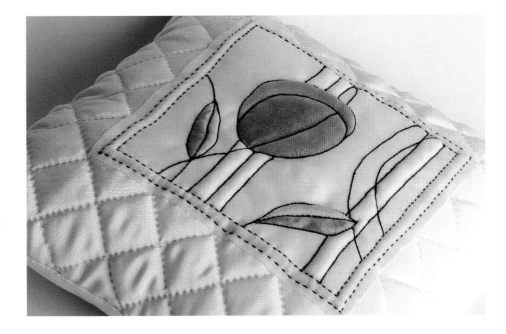

EMBROIDERY SAMPLES

■ Choose co-ordinating colours and threads for the samples. The basic colour palette of mauves, rose, soft green and blue grey used by Charles Rennie Mackintosh is an ideal starting point. Try the same motif in a number of techniques or the same technique in several colourways or different fabrics. If you are new to embroidery, the techniques section (see pages 104–120) provides clear instructions for a range of methods that can be employed for these samples.

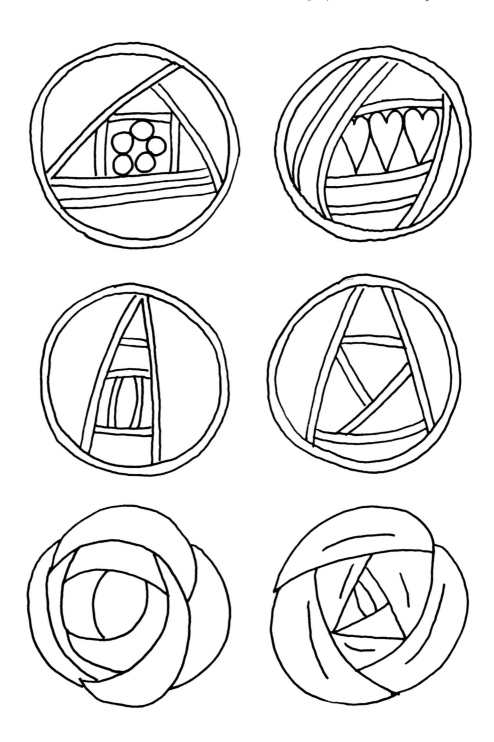

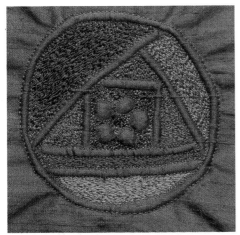

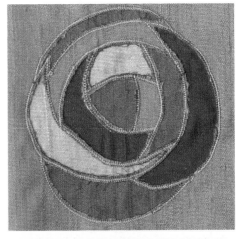

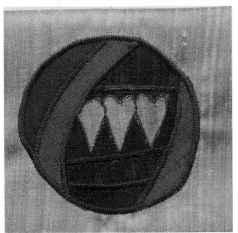

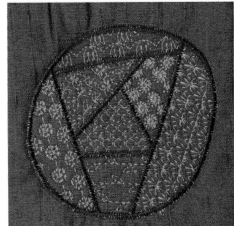

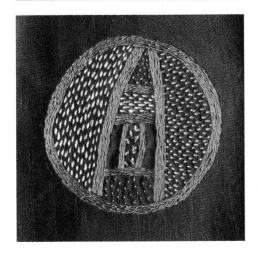

Hand embroidery: use basic stitches such as French knots, running stitch and long-and-short stitch to create areas of colour and texture. To prevent the fabric puckering, back with calico and stretch in an embroidery hoop.

Quilting: tuck a layer of thin wadding between the top fabric and a firm calico base and tack securely to avoid the need for an embroidery hoop when machine stitching. Areas of the quilted design can be stuffed with extra padding from the reverse side.

Top row, far left: Trapunto quilting. Unlike traditional quilting, in Trapunto the padding is added after the fabric has been stitched. Machine or hand stitch along the design lines, leaving enough room for a needle. Pull quilting wool down the channels from the reverse side.

Top row, left: Reverse appliqué. Layer several different fabrics together. Stitch the motif and then cut back through the layers to reveal the colours below. A firm machine stitch will allow you to cut close to the stitching, although a deeper edge that frays can create an unusual surface.

Middle row, far left: Appliqué. Traditional appliqué requires careful preparation, pinning and tacking before using firm, close stitching to hold the patch in place. Bonding paper eliminates the need for pinning and tacking and as a result the design can be finished in a freer style.

Middle row, left: Machine embroidery: Motifs can be stitched conventionally or with freestyle embroidery. The set stitches on your machine can be used to create Sashiko-style patterns. Back the fabric with calico to give it a firm base and use an embroidery hoop for freestyle.

INSTANT ABSTRACTS

Rather than working from a whole motif, you can take a small section from a Mackintosh rose design and blow it up to create an abstract image. Choose a fairly simple colour image with bold lines. Cut two 'L' shapes in black card and hold them together to make a square or rectangle. Move the 'window' over the image until you see a pattern that you like. Sketch several such images in a larger scale. This simple exercise produces interesting results that can be used to create a design for embroidery or for further development.

This page from Ena Dean's workbook shows the design motif and the sections that were chosen for further development.

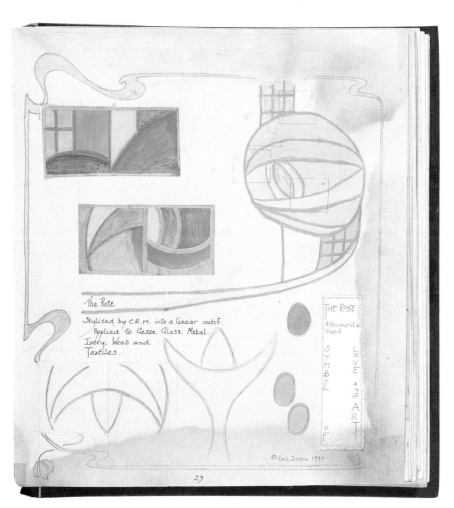

OTHER FABRIC TECHNIQUES

Roses also appear in a range of sizes in the art of the period. As well as large motifs for stencilling or stained glass, there are very small roses on long tendrils in many of the paintings and gesso panels, and this range of sizes can be a challenge for the embroiderer. A single French knot can represent a tiny rose and slightly larger roses can be worked in bullion stitch. There are several ways to make roses in ribbon embroidery or you could even make realistic ribbon roses by gathering one edge of the ribbon and wrapping it round and round until the rose is the required size.

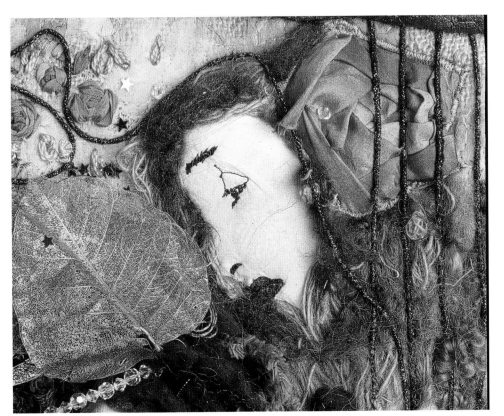

Sandie Maher has been inspired by the work of Mackintosh and his wife, Margaret Macdonald for a number of years and has created a series of beautiful embroideries based on the gesso panels. She used a range of techniques, such as patchwork and ribbonwork to create roses in her large embroideries. The patchwork roses are made from space-dyed fabric and padded from behind to create the raised effect. Pieces of fabric were folded in half and arranged on a base to create the overlapping effect of the rose petals. The outer edge was machine stitched to form the shape of the rose and the excess fabric trimmed away.

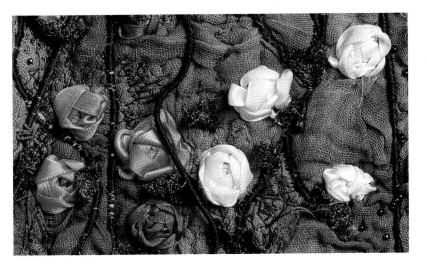

Ribbon embroidery roses: work a French knot for the centre and then work concentric circles of loose stem stitch until the rose is the required size. Alternatively, stitch the framework for a spider's web in embroidery thread and then weave in and out in ribbon.

■ Stencilling was a favourite technique for Charles Rennie Mackintosh, because the clean-cut edges of the stencils suited his style and it was also a cost-effective way to create large areas of pattern. He used it extensively in his interiors to decorate all manner of surfaces from walls and fabric to painted woodwork. This use of a similar motif on different surfaces had a unifying effect on the interiors and helped to pull the various elements together. The rose, one of his favourite motifs, was often combined with straight lines, grids and squares to create a larger abstract design.

DEVELOPING IDEAS WITH STENCILS

USING STENCILLING IN EMBROIDERY

■ Stencilling is a quick and easy way to transfer motifs to fabric. The stencil itself can be cut from a range of materials depending on how often the motif is to be repeated. Paper or thin card is ideal for one or two prints but a more permanent stencil can be made from acetate or Mylar paper. To create a clean-edged motif, spray the reverse side of the stencil with spray-mount adhesive and apply the fabric paint with a stencil brush or sponge. For a more unusual effect, apply paint sparingly with a sponge or lift the stencil slightly and spray to create a ragged edge.

CUT PAPER AND TISSUE

■ Charles Rennie Mackintosh used the idea of looking through or letting light through materials to create interesting furniture and interiors and this concept can be applied to develop design ideas for the roses. For inspirational ideas use the stencils to make cut-out paper patterns and layer them with stencil prints, drawings, paintings or even coloured paper. Draw round the shapes in the stencils on paper and then cut out the shapes with a craft knife. Hand dye your own papers – Tissuetex (abaca tissue) is ideal for dyeing – or use ombré tissue paper to create unusual effects and stitch over the designs with simple machine embroidery.

Rose motif designs can be developed using a variety of papers and machine stitching.

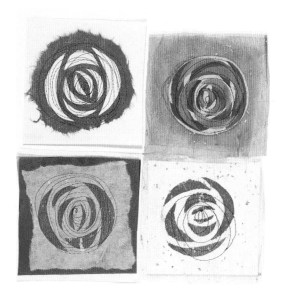
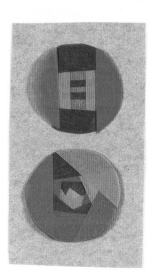

Michelle Foster is fascinated with cutting out areas and incorporating designs behind the cut-outs and has applied this idea to the rose motif. After painting and drawing various rose motifs in line and colourwash, she then looked at the different effects that can be achieved with paper cut-outs. Sticky pads were positioned between the background design and the cut-out to create a three-dimensional effect. This inspiration work was used to develop several cushion (pillow) panels.

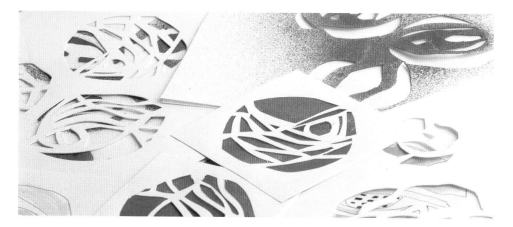

■ This delightful little bag, inspired by a mosaic-tile insert at the Mackintosh-designed Hill House in Helensburgh near Glasgow, incorporates a variety of the techniques used in the embroidery samples. Quilting, hand embroidery and appliqué were chosen to create the rose motif, with layers of fabric and quilting making the main body of the bag. The finishing touches are applied beads in the rose motif and a matching chain of beads for the strap. The muslin for appliqué was dyed in shades of pink to match the thread colours.

Shadow quilting creates a subtle range of colours for the rose motif and striped panel (Dorothy Wood).

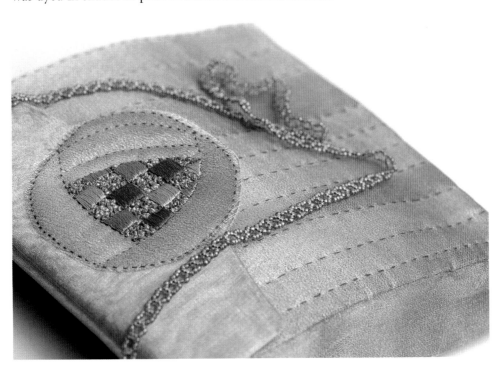

You will need

Grey metallic organza

Calico

Cotton wadding and polyester wadding

Pink frosted sheer fabric

Pale-pink muslin

Fuchsia muslin

Grey metallic muslin

Pink lining fabric

Pelmet Vilene

DMC stranded cotton: grey 3799

DMC rayon threads: pale pink, mauve and fuchsia

Mill Hill beads: 2018 and 2014

Bonding paper

Template for rose motif on the front panel of the bag.

Working the rose motif

1 Reverse the rose motif and trace individual sections a little apart on bonding paper. Cut out with a slight border and iron the sections onto the different shades of pink muslin. Plan the design so that adjacent areas are not the same colour. The centre and one of the sections can be left without appliqué.

2 Cut a 25 x 35cm (10 x 14in) piece of grey metallic organza and lay it on top of the template so that the bulk of the fabric is lying above the motif. This excess fabric will become the back panel of the bag. Peel the backing off the bonding paper, arrange the sections and iron in place. Tack the outline of the bag on the grey metallic organza.

3 Cut pieces of calico, cotton wadding and pink frosted sheer the same size as the grey metallic organza. Layer with the calico at the bottom, then the cotton wadding and frosted pink under the grey metallic. The rose motif is padded with an extra layer of polyester wadding. Cut a piece of thin polyester wadding the same size as the rose motif and tuck between the cotton wadding and sheer fabrics.

4 Lay a 10cm (4in) square of pink sheer fabric over the appliqué and tack the layers together. Using a single strand of grey embroidery thread, work running stitches along all the lines of the motif.

5 Work blocks of satin stitch on alternate squares in the rose centre and fill the other squares with French knots in mixed shades of pink. Stitch beads among the French knots to complete the embroidery.

6 Trim the square of pink frosted fabric close to the stitching around the rose motif. The back of the bag is decorated with lines of grey running stitches in a similar layout to the template without the rose motif.

Making the front panel

1 Draw 25-cm (10-in) long strips on bonding paper to match the width of the strips in the template. Three or four of the strips on the template will not need appliqué. Iron half the remaining strips onto pale-pink muslin and the rest onto fuchsia muslin.

2 Cut 25-cm (10-in) squares of pink frosted fabric, grey metallic organza, cotton wadding and calico. Lay the grey metallic muslin over the template and iron the strips in place so that adjacent strips are different colours. Lay the pink frosted sheer on top, and layer the wadding and calico underneath. Work grey running stitches down the sides of the strips.

Making the bag

1 Layer the same fabrics to make two 5 x 25cm (2 x 10in) pieces for the side panels. Cut pieces of lining to match each of the bag sections. Line the side and front bag panels by stitching the lining to the prepared panel along the top edge and pressing the lining to the reverse side.

2 To line the embroidered bag panel, stitch around the rose motif to the top edge of the bag as indicated on the template. Snip into the corners, notch the curves and turn through.

3 Tack the exact shape of the bag panels on each piece of prepared pink lining fabric, keeping the lining free on the front and back panels. Stitch the back and front panels together, then stitch the side seams, keeping the front and back lining free.

4 At this stage, the bag can be stiffened with pieces of pelmet Vilene cut to shape and inserted. Hand stitch the remaining seams of the lining.

5 Make a strap for the bag using cable stitch. Pick up two light-pink seed beads, two dark-pink, two light-pink and another two dark-pink seed beads and tie into a circle. Take the needle back through the last two dark beads and two light beads. Pick up two light, two dark and two light beads. Take the needle through the two dark beads already threaded and through the first two light beads just added. Repeat from the asterix until the strap is the required length. Attach the strap securely to the sides of the bag.

GOING LARGE

One of the most exciting aspects of embroidery is the ability to change the scale of a piece of work. If you are used to working on relatively small embroideries it can be quite a challenge to 'go large' and create a much bigger piece of work than usual. Many embroidery courses stipulate a minimum size for final pieces of coursework and this inevitably stretches and develops the embroiderer and usually leads to a much more advanced design.

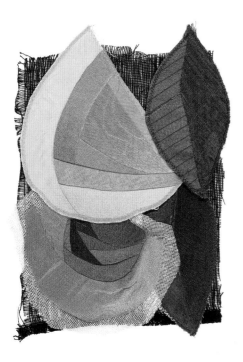

Preparation and careful planning are essential when working on large pieces. Making samples of the different areas is vital so that any problems are solved before the work commences.

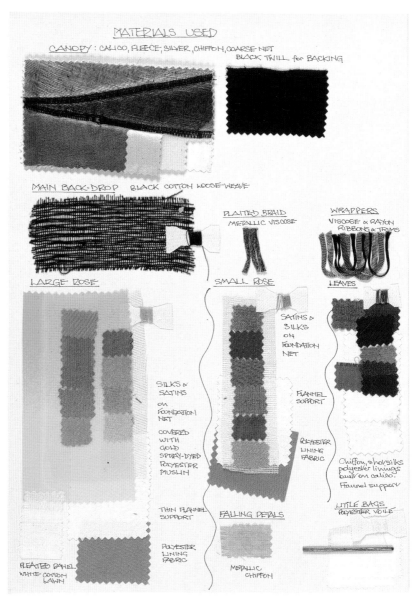

A careful record of the materials used in the design is useful for future reference.

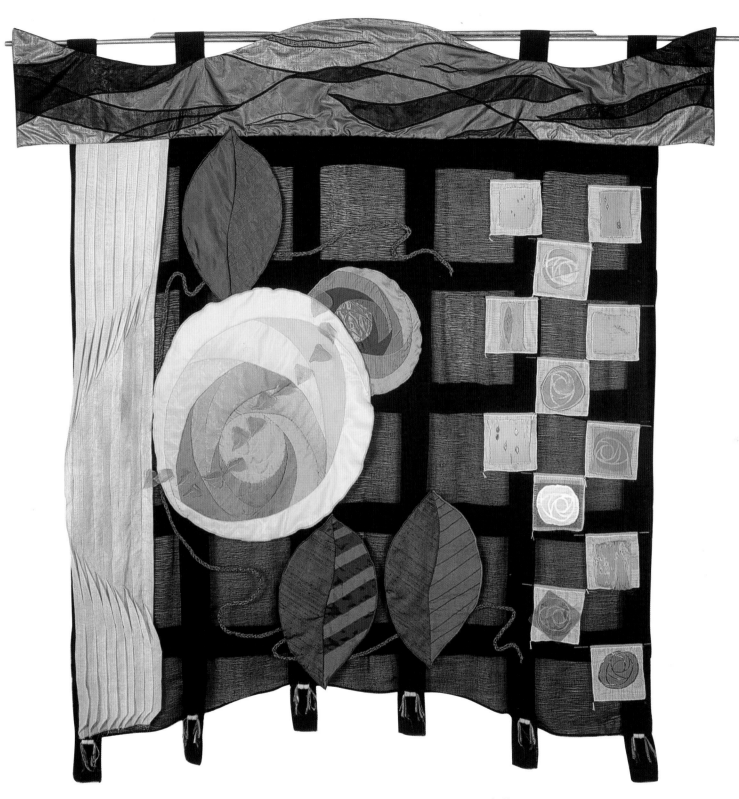

Beryl Smith used a variety of fabric techniques to create this stunning wall hanging some 150 cm (5 ft) square. The mauve and apricot colour scheme was developed from research into Rennie Mackintosh's textile designs. The background fabric was made by carefully folding and stitching black muslin to create the bold grid pattern. The panel on the left-hand side is tucked and folded to reveal the reverse colours. The small squares on the right-hand panel are smocked to create texture and add a three-dimensional quality.

3
SQUARES
AND
LATTICES

■ Square-motif and lattice patterns featured extensively in Charles Rennie Mackintosh's designs in the middle and latter part of his life. His early designs were mainly inspired by feminine organic motifs, which reflected the influence of contemporaries such as Margaret and Frances Macdonald. To offset the feminine nature of these early designs, Mackintosh began to use bold geometric patterns and darker colours to add a more masculine perspective to his work. Eventually, squares and lattice patterns were used as a design element in their own right, appearing in much of his work whether it was furniture, furnishings or buildings.

There are two schools of thought about what inspired Mackintosh to create such distinctive square patterns and grids. On one hand, the street maps of his home city may have fired his imagination. In the same way as New York, the streets in Glasgow city centre are built on a grid system and maps of the city look very similar in scale and layout to the latticework in his designs. On the other hand, the influence may have come from Japan. The shoji paper screens found in every Japanese home could have inspired his latticework designs. At the time, Glasgow was a busy commercial port with strong links to the Orient and many artists were inspired by Japanese art and design. Japonaiserie, or furnishing and decorative objects with a Japanese flavour, was extremely popular and indeed *de rigueur* in the most fashionable homes. Mackintosh was an avid admirer of Japanese style and designed several stunning pieces of furniture in the shape of a kimono. His chairs were constructed in a similar way to the folk designs of Japanese furniture, with the simple lines and shapes reflecting the Japanese style. He must have admired the uncluttered elegance of Japanese interiors and used the concept of yin and yang in his work by combining opposites such as feminine/masculine, dark/light and straight/curved to great effect.

His designs using the square-motif and lattice patterns were often in dark wood and they have a distinctly masculine feel. The pieces of furniture and interior designs in this style were usually made for libraries or studies and he reserved the white, light schemes for living areas and bedrooms, which had a more feminine quality. Mackintosh used this contrast between the masculine and feminine aspects of design in much of his stained-glass work when soft organic shapes such as roses and seed heads were offset by strong geometric squares and rectangles.

Mackintosh used the square motif in many innovative ways in his designs. Mother-of-pearl squares were inset into dark wooden doors, often on the interior of the

door to create an element of surprise. Rows of brightly coloured stained-glass squares were inset in rows along pelmet boards, down the side of clocks or into panels in staircases so that the light could shine through during the day. The backs of chairs or pieces of furniture had square holes cut out or were made from latticework to lighten the heavy dark wood, and walls were stencilled with blocks of squares with carpets commissioned to match. It was this holistic approach that singled Mackintosh out from other architects and designers. His astute use of repetitive shapes and motifs pulled all elements in the room together, creating a unique atmosphere.

DEVELOPING IDEAS

■ The constant repetition of particular arrangements of squares and distinctive lattice patterns developed into the characteristic style that is instantly recognized as that of Charles Rennie Mackintosh. Although simply constructed from straight lines or square blocks, it is the size, shape and juxtaposition of these lines and squares that give the designs his own particular quality. As a result, careful consideration is required when developing the original squares or lattice patterns into a design for embroidery.

Cut paper is an ideal medium for developing ideas. Because much of Mackintosh's geometric work is dark, begin by cutting squares and strips of black paper and arranging them into the patterns he used. Think about the gaps between the squares and the thickness of the lines when trying to re-create the style. Your worksheet will be an ideal reference for later development and act as an *aide-memoire* for future design ideas.

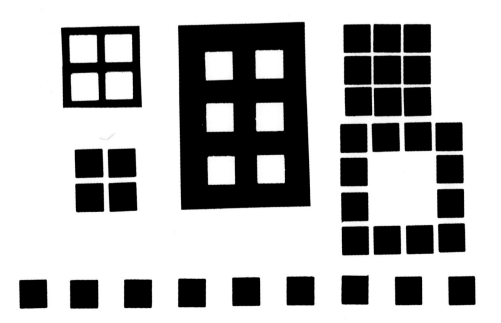

Cut black paper into squares and grids and arrange in different ways in your workbook.

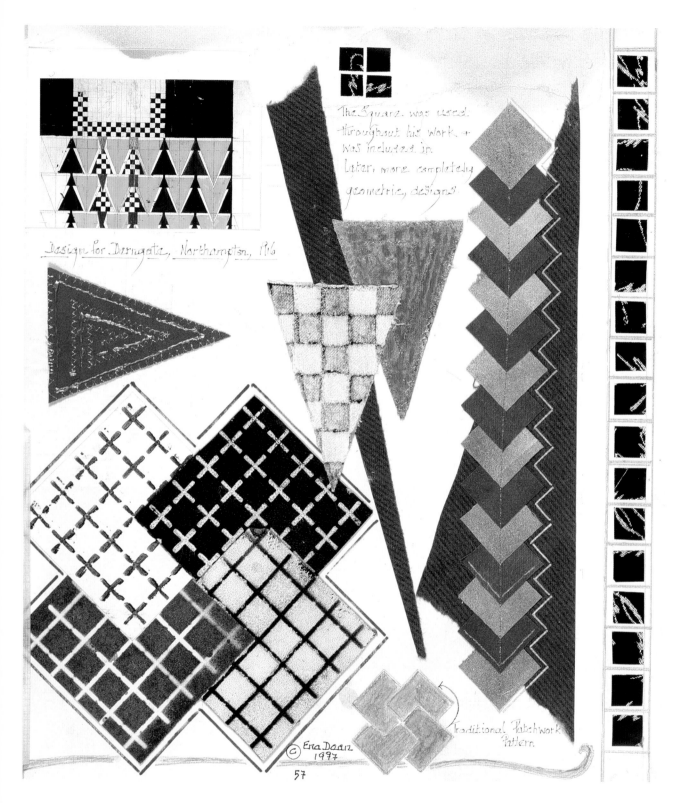

Design for Derngate, Northampton, 1916

The Square was used throughout his work & was included in later, more completely geometric, designs.

© Ena Dean 1997

57

Traditional Patchwork Pattern

Ena Dean has used a variety of cut paper and printing techniques to develop ideas from square motifs and grid patterns.

Apart from stencilling, much of the colour in the Mackintosh interiors came from stained glass. This material was used not only in the conventional way for lampshades and windows, but also featured as insets in furniture or in place of tiles in washstands and other similar pieces. The colours are generally in Mackintosh's familiar tertiary colours, but they are much brighter and bolder than the stencilling used elsewhere in the room. One of the attractive qualities of stained glass is the mottled, variegated colour that can shade right through from light to dark in one section. You can use toning shades of fabric to re-create the subtle changes of colour or alternatively dye your own fabrics.

The stained-glass panel at the back of a Mackintosh washstand was specially commissioned by Walter Blackie, a wealthy Glasgow businessman, to match an existing chest of drawers and also inspired the fabric samples below. They show different ways to create subtle shades of colour and a mottled appearance from simple appliquéd squares of fabric:

• Bonding fabric painted with pearlized fabric paint was cut into squares and ironed onto the appliquéd fabric (left-hand image below). More pearlized paint was sponged over the whole piece before quilting.
• Instead of sponging with paint, Sizoflor (angel hair), a web-like fabric was laid over the whole piece before quilting (right-hand image below).
• Each square was covered in long straight stitches in a co-ordinating thread and then the whole piece stitched into with a subtle variegated metallic thread.

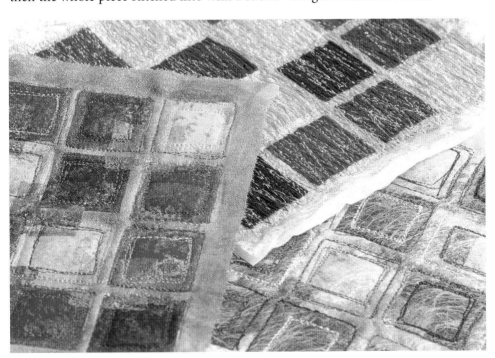

Different techniques were used to create similar designs from one source.

Silk/viscose velvet has been painted on the reverse side and heated to create this devoré velvet. The quilted pieces have been machine stitched in the gaps created by the devoré process to create rich textured samples.

TRYING A NEW TECHNIQUE

■ It can be an intriguing exercise to try a new technique for inspiration and to use the resulting work and samples for further development and a possible finished piece. With a bias towards the use of fabrics available at the end of the 19th century, look for techniques that work predominantly with natural fibres even if the technique itself is relatively new. Discharge cotton, batik and silk painting would all be inspiring techniques with which to experiment. You could also try making devoré velvet, a striking textured fabric that has areas of the velvet pile removed to leave the sheer background fabric. The fabric used for the technique is a silk/viscose velvet that has a beautiful quality and takes dye very well. Fibre Etch, a special liquid that dissolves cellulose fibres, is painted or screen printed onto the reverse side of velvet, allowed to dry and then ironed until the image turns dark brown. When washed under running water, the pile falls away leaving the raised areas of pile and sheer background fabric. The new devoré fabric can then be dyed and stitched to create different effects.

As you look for different square patterns in Mackintosh's designs, you will begin to notice the different media he worked in and the different effects he achieved with the same pattern or motif. Although very simple in design, much of his work with squares is interesting to study because it centres on the juxtaposition between the actual design and its surroundings. For example, Mackintosh always liked the idea of enclosing or cordoning off an area while still linking it to other areas. This was used to great effect in his dining-chair designs: when everyone was seated at a table the high backs formed a screen, giving an impression of privacy, while the use of latticework or inset glass panels broke up the solid surfaces. You can use these design elements to develop different ideas with cut paper. Try transparent or translucent paper to re-create the feeling of looking through and use colours that

LETTING THE LIGHT THROUGH

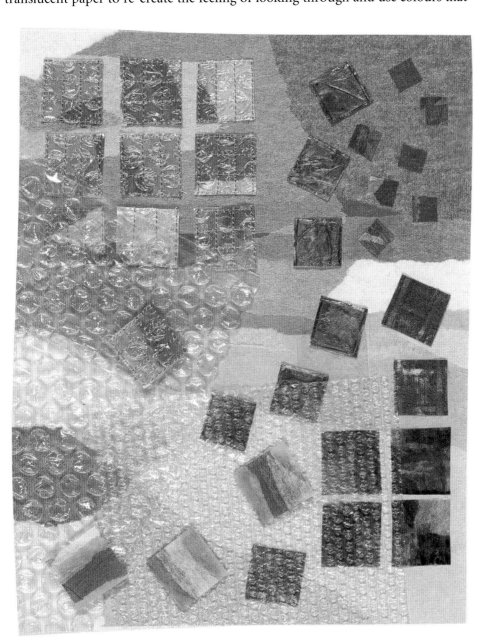

Use a range of different papers and materials to create translucent patterns with squares and grid patterns.

are in Mackintosh's stained-glass windows and panels to develop the designs. There are many different plastic materials suitable for stitching on. Look out for packaging in supermarkets such as fine bubble wrap, which is often used to keep a range of produce. These materials can be layered with coloured paper or painted before stitching. Try monoprinting to create unusual coloured papers. Use a roller to spread a thin layer of paint on a sheet of glass. Draw a pattern into the paint and then lay the paper on top. Alternatively, you can lay the paper over smooth paint and draw directly on the paper to create an interesting effect.

TRYING OUT IDEAS

Use sheer fabrics and ribbon to make experimental samples.

■ To achieve this feeling of looking through or beyond the square and lattice patterns, try some of your ideas out using sheer fabrics. Alternatively, try pasting strips of torn tissue paper in co-ordinating colours on a sheet of plastic (such as a clear document pocket). Once dry, the resulting 'fabric' can be peeled off and stitched into by hand or machine. Pelmet Vilene is a very firm material that accepts dye readily and can be used to form a solid framework for these sheer areas. Use ribbons, braids or strips of fabric to form the lattice patterns.

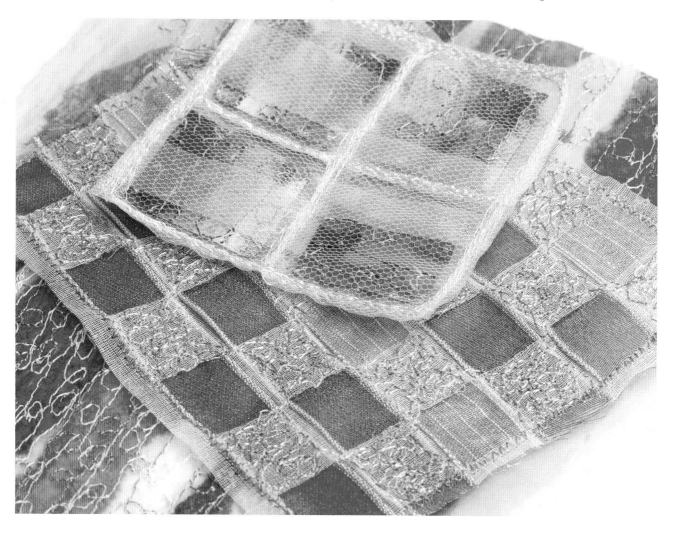

Charles Rennie Mackintosh enjoyed using light to enhance his interiors and as a result his window dressings were as simple as possible. In his white interiors he used sheer muslin curtains (drapes) that were little more than flat panels embroidered with organic motifs and were often edged in black binding. These delicate curtains (drapes) screened the window while still allowing the light into the room. His stained-glass windows had a similar effect, diffusing the strong sunlight.

WINDOW
DRESSINGS

Try out different threads and machine-embroidery patterns on organdie to find which gives the effect you are looking for.

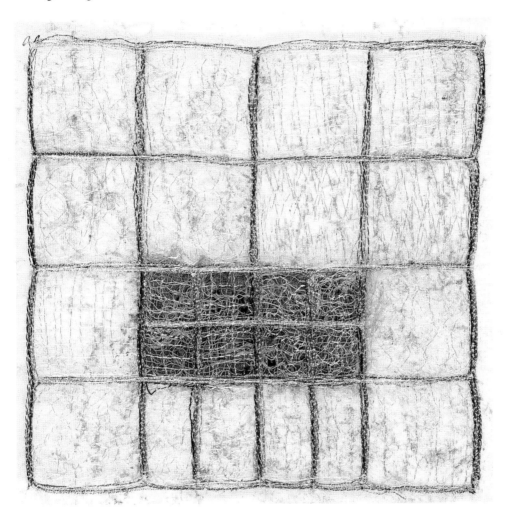

This embroidered panel, which could be used as a window blind (shade) or simple hanging panel, brings both of these ideas together (see page 46). A design in a grid of squares was pencilled onto plain cotton organdie and then the entire area was sponged with several subtle pearlized fabric paints to create a mottled background. Cut strands of variegated threads were scattered on some of the squares, and rectangles of dyed muslin and scrim were pinned on top to create the beautiful mottled stained-glass areas. A loop pattern was machine stitched over the entire surface in a subtle metallic thread and then the pattern was repeated, slightly offset, in a plain thread. This is fairly straightforward as organdie is a stiff fabric

MAKING
A WINDOW
BLIND

that doesn't pucker when worked without a hoop. The grid pattern was stitched in solid machine stitching using plain and metallic threads. To finish the design, a hand-dyed viscose ribbon was stitched across some of the grid lines and also round the outside edge. The excess fabric was trimmed close to the ribbon.

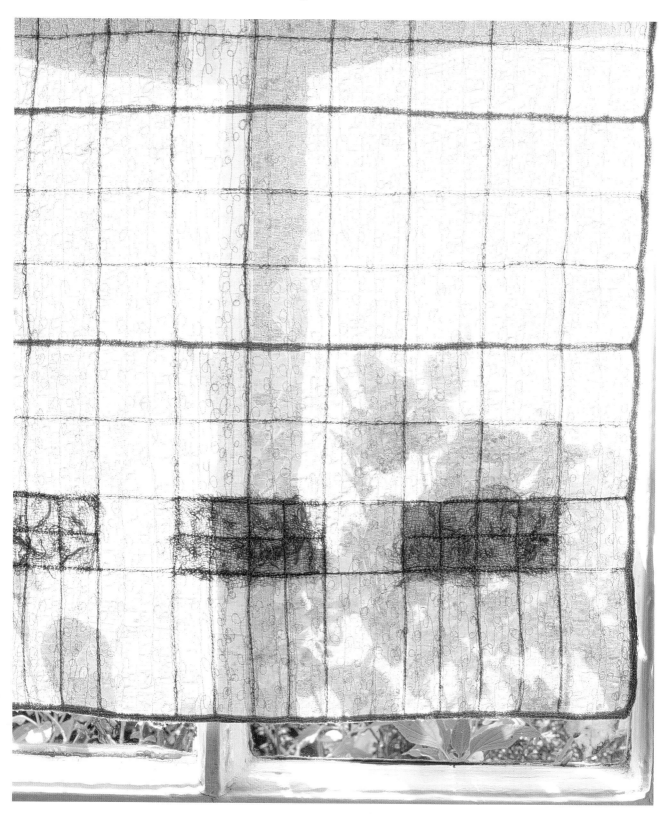

■ Water-soluble fabric are ideal for re-creating the lattice effect in Charles Rennie Mackintosh's designs. New water-soluble fabrics have been developed in recent years that are much easier to use and less prone to tear. There is a paper fabric that is perfect for light stitching and can be worked without a frame. A new adhesive water-soluble fabric is ideal for holding pieces of appliqué or threads in place while stitching and can be used in conjunction with other water-soluble fabrics. This can keep costs down as the adhesive is only required where fabrics and threads need to be held in place. There is no limit to the number of layers of water-soluble fabric used in one piece, although there will be a build-up of glue residue in thicker areas when the stitched piece is rinsed. This build-up of glue can be part of the design and the resulting stitched pieces can be quite stiff. To create an even stiffer fabric suitable for boxes, bowls and other structures, use the heavyweight version. This clear plastic material is the easiest to stitch on and several layers of stitching can be worked without tearing. There are many different makes of dissolving fabric and only trial and error will let you decide which you prefer.

When stitching with water-soluble fabric, it is important to work the main lines of the design several times so that the whole structure holds together. If the stitched lines are inadequate, the whole piece will not hold its shape and may even disintegrate when the soluble background fabric is washed out. When stitching grid lines with straight stitch, work one of the foundation rows with a zigzag stitch or weave gently across the stitching once or twice to catch in the side threads.

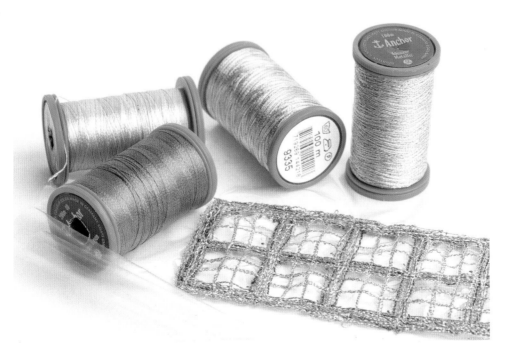

When using watersoluble fabric, go over the design lines in several different colours and types of thread to build up a solid fabric.

Lattice box

The box is created in sections and stitched together once all the pieces have been rinsed and dried. Along with the heavy-weight water-soluble fabric, you will need Anchor threads: alcazar nut-brown 447, dark blue 150, mink 429, pale-pink/green variegated metallic 9335, soft-peach metallic 9311. Cut squares of metallic organza for the border on the sides and lid.

1 Mark the outline of the section to be stitched on the water-soluble fabric (see template and caption opposite). Use 447 or another nut-brown cotton machine-embroidery thread in the bobbin throughout. Set the machine for straight free machine embroidery and stretch the water-soluble fabric in a hoop. Stitch along all the marked lines in nut brown and again in between to make three lines of stitching.

2 Change the top thread to dark blue. Stitch between the marked lines twice in dark blue, weaving the lines slightly from side to side as you stitch.

3 Change the top thread to the soft peach metallic. Stitch in the same way as the dark blue and then stitch across each of the squares twice in each direction to divide the squares into nine.

4 Change the top thread to the variegated metallic thread. Weave across the thick grid lines to catch in all the previous stitch lines and then stitch backwards and forwards to create heavier stitching. Finally, change the top thread to mink. Stitch over all the previous stitching.

5 For the side panels, cut out five squares in metallic organza and stick to a piece of adhesive water-soluble fabric correctly spaced out. Lay the heavy-weight water-soluble fabric on top, lining up the grid with the squares of fabric. Stitch the grid as before.

6 The lid has a row of metallic organza squares all round, and the base of the box is covered entirely with fabric squares for stability.

7 Rinse all the pieces to remove most of the water-soluble fabric but don't over rinse as you need to keep some stickineess to give the box rigidity when it dries. Join as many seams as possible by butting the edges together and stitching back and forth by machine. Hand stitch the remaining seams to complete the box.

Inspired by Mackintosh's lattice chairs and stained-glass lampshades, this delightful little box was stitched on heavyweight water-soluble fabric. Squares of sheer metallic organza were held in place with the adhesive water-soluble fabric before stitching. The sections of the box were all stitched separately and assembled by machine as far as possible, then finished by hand. The pieces all look the same because the sequence of stitching each layer of thread and the number of rows in each colour was recorded and repeated for each subsequent piece. The same soft nut-brown thread was used in the bobbin throughout.

Lay the water-soluble fabric over this grid and trace the design for the lid, base and side panels. Trace the bottom row only for the lid rim. Use the template to cut squares of metallic organza.

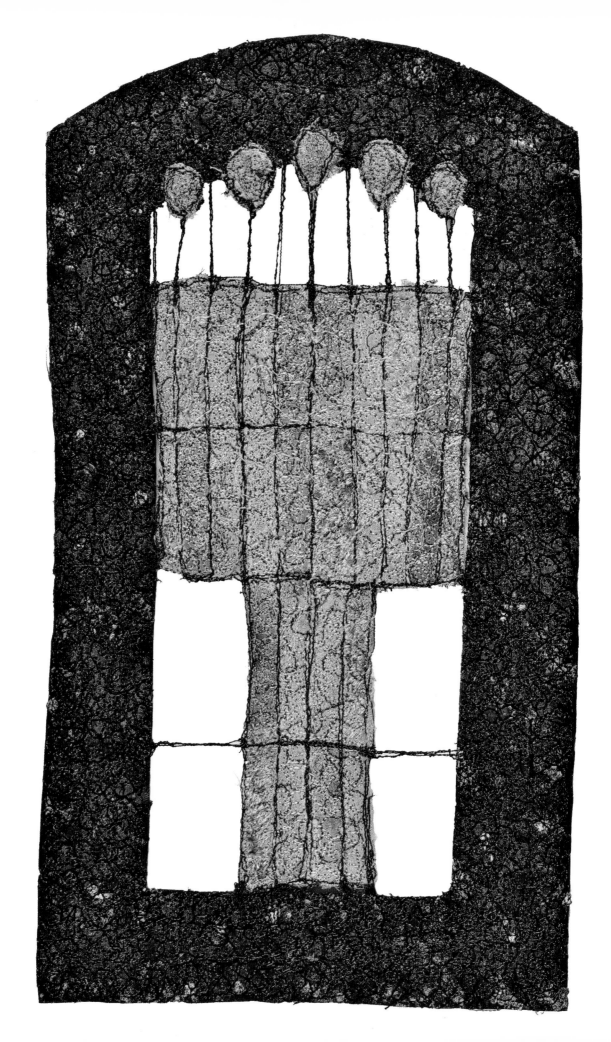

4

SEED HEADS AND OTHER ORGANIC FORMS

▧ Charles Rennie Mackintosh's interest in natural forms began at an early age. His father devoted all his spare time to gardening, and passed on his passion and knowledge of plants to his son. He instilled in Mackintosh a love of the natural world that provided inspiration for his art and craft throughout his life.

Charles Rennie Mackintosh enrolled at the Glasgow School of Art at the age of 15 and began training as an architect in the offices of John Hutchison a year later. He was a keen worker with ambition, so he worked in the office during the day while continuing to study art in the early morning and evening. Later he moved to another architectural practice, Honeyman and Keppie, where he met his friend Herbert MacNair who also studied at the Glasgow School of Art. The principal of the art college, Francis Newbery, noticed a similarity in their approach to design between Charles Rennie Mackintosh, MacNair and Margaret and Frances Macdonald and encouraged them to work together. The rapport between 'The Four' was instantaneous and their close collaboration soon developed into an identifiable style. The naturalistic approach to their work, which centred on undulating lines and elongated organic forms, had obvious links with Art Nouveau and Symbolism.

Charles Rennie Mackintosh was clearly influenced by the feminine nature of the womens' work but he soon developed his own style, focusing on images of growth such as seed heads, leaves, roots, stems and branches. These stylized organic forms became the basis for many of his interior and furniture designs. As Mackintosh's confidence grew, he began to see himself as an artist rather than as an architect. He was never frightened to use ornament in his furnishings and interiors, striving to unite the masculine qualities of structure with the softer feminine role of decoration. The skills that Mackintosh learnt at the Glasgow School of Art gave him the opportunity to use a wide range of craft media to create his designs. Stained glass, stencilling, woodcarving, mosaic and metalwork are just a few of the ways that Charles Rennie Mackintosh introduced decoration to his designs. A motif carved in wood has a completely different look to a similar design in stained glass or stencilling and studying these organic motifs and designs in a diverse range of media provides a huge creative resource for embroiderers.

THE WILLOW
TEA ROOMS

▧ Charles Rennie Mackintosh's innovative, holistic approach led to a series of commissions from Kate Cranston, a Glasgow businesswoman, who had plans to create 'Art Tea Rooms' in the city.

His first commission for her, a series of murals, was so successful that he had an increasing role in each of the subsequent tea rooms culminating in his complete control over the building and interiors for the Willow Tea Rooms in Sauchiehall Street in Glasgow. He designed everything from the furniture and light fittings to the menus and signboards but one of the most distinctive features is the beautiful stained-glass door at the entrance to the

Using two 'L' shapes allows you to alter the size and shape of the aperture to find suitable designs.

Once you have selected interesting areas, remove, alter or add lines to create a more pleasing design.

'Room De Luxe'. The overall design is in the shape of a kimono but includes the rose motif as well as stunning seed-head patterns. Because the doors are so large, it is sensible to concentrate on one small area for inspiration.

Working a sample inspired by the stained-glass door in the Willow Tea Rooms

1 Photocopy a picture of the doors, enlarging it to a suitable size or alternatively draw out the whole design.

2 Cut two 'L' shapes of black card that can be used to make a window to isolate part of the design ('L' shapes allow you to alter the size and shape of the aperture). Move the card over the design until you find an area that makes an attractive pattern in its own right. Sketch or trace the area and enlarge it to a suitable size to work with.

3 Make several sketches using this design as inspiration. You may want to keep proportions and shapes true, but alter some of the design lines to make the design your own. Once you are satisfied with the design, colour areas until you achieve a pleasing overall balance.

Ena Dean has used a section of the famous stained-glass door in the Willow Tea Rooms to create a design for the front of her Charles Rennie Mackintosh workbook.

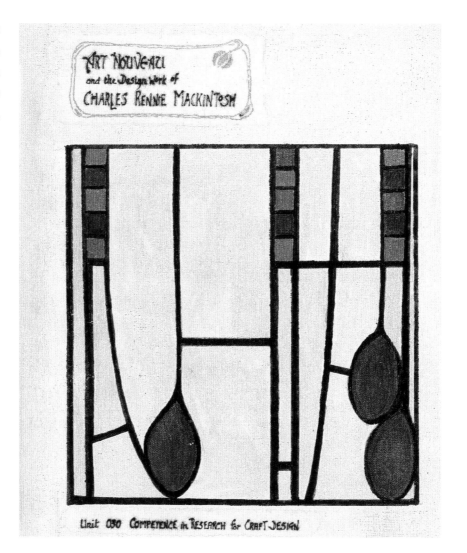

Art Nouveau and the Design Work of CHARLES RENNIE MACKINTOSH

Unit 030 Competence in Research for Craft Design

WORKING IN FABRIC

■ There are many techniques and styles of embroidery that can be used to create a stained-glass design in fabric. The linear style of a pattern where all the lines are linked lends itself to machine embroidery worked on water-soluble fabric. Alternatively, the solid areas could be appliquéd with couched threads or braid for the leading. Reverse appliqué is another possibility, or the design could be created using handmade felt and machine embroidery. Try out different techniques in small fabric samples before making a final decision.

STAINED-GLASS APPLIQUÉ CUSHION (PILLOW)

■ To keep the clean lines and subtle colours found in the inspiration source, this cushion (pillow) has been worked in stained-glass appliqué. This simple technique is ideal for a cushion (pillow) cover as the applied fabrics and bias tape are stitched securely. Fine silk is not suitable for appliqué with bonding paper and so the pieces are stitched in place before the bias tape is applied (see techniques on page 112).

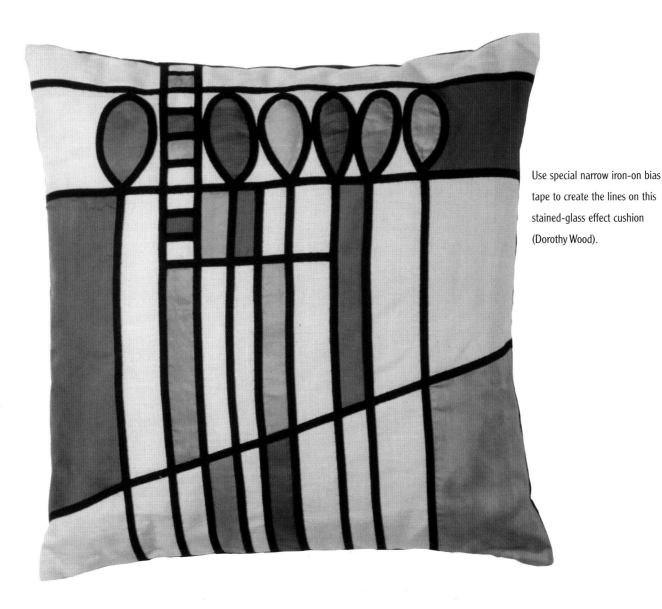

Use special narrow iron-on bias tape to create the lines on this stained-glass effect cushion (Dorothy Wood).

DYEING FABRICS WITH SILK PAINTS

■ It is difficult to buy fabrics in the subtle colour range used for the appliqué cushion (pillow) shown above, but silk can be dyed quite easily with silk paints. As the fabric is dyed flat, you can mix colours as you would paint and know exactly what colours will result before the fabric is left to dry.

Start by stretching the silk on a frame. Then mix the silk dyes in a palette to create a range of shades from mauve to purple. Remember that the colour will be slightly lighter when the fabric dries. Use a sponge brush to colour areas of the silk in each shade. The silk paint will spread slightly, so leave a little plain fabric between each colour. Allow the fabric to dry and then set the dye by ironing at a medium heat for several minutes.

QUEEN'S CROSS CHURCH

St Matthew's Church, as it was then known, was designed by Charles Rennie Mackintosh and built on an awkward site at Queen's Cross in Glasgow in 1897–99. It is now the headquarters of the Charles Rennie Mackintosh Society. At first glance, the church appears quite conventional but closer inspection reveals some stunning decorative details. Built at a time when Mackintosh was inspired by organic motifs, in particular seed heads and leaves, there is a wealth of design inspiration in all areas of the church. Outside, above the doors and windows there are wonderful organic stone carvings. Inside there are dozens of intricate carvings on the pulpit, in panelling behind the pulpit, on the communion table and on the pews that could be used as a basis for embroidery. One of the fascinating things about the motifs is that rarely are two identical. Even when there are a series of carvings, they may look the same from a distance, but on close inspection, each is shown to be slightly different.

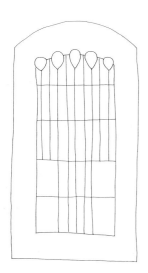

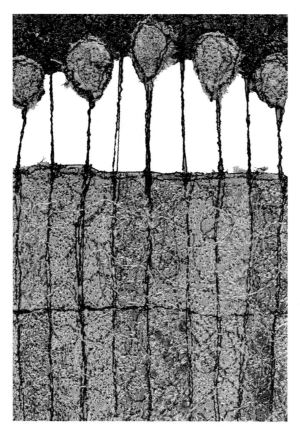

This tiny sampler was inspired by one of the stained-glass windows in the Queen's Cross Church in Glasgow. (Full image on page 50; Dorothy Wood.)

There are two sets of Gothic-style stained-glass windows in the church. The window at the front of the church is based on the heart motif and features a stunning deep-blue glass. In complete contrast, the window at the back of the church incorporates a seed-head motif within a bold grid pattern and is made from vibrant green glass.

Different fabrics such as silk, muslin and silk viscose velvet were dyed using the bag method explained in the techniques section (see page 106) to create a range of green fabrics with shades of yellow and blue. Using the template as reference, the fabrics were cut into small rectangles and seed heads then stuck onto water-soluble adhesive fabric. This panel was covered in a larger piece of ordinary water-soluble fabric before stitching. The fabrics were stitched in a vermicelli pattern to create texture and blend the fabrics together and then the outlines were stitched in black or dark grey.

The frame (see page 50) is made from pelmet Vilene that was cut to fit the finished stitched piece. Expandable paint was sponged on very lightly and then the frame was dyed with black ink. Small torn pieces of black and gilt tissue paper were laid over the frame and then stitched down with machine embroidery to create a rich texture. The fabric panel was pinned and then stitched in place by machine.

■ Sometimes, when you are trying out ideas, a technique such as sponge dyeing on reverse appliqué is so inspiring that you will want to try out the idea in a project. The dyed sample below was originally part of a study of Mackintosh's square motifs but needed a stronger design to make the most of the technique. There are many examples of organic motifs based on seed heads and leaves in Charles Rennie Mackintosh's work that could be adapted or used as inspiration for a design incorporating this technique

LOOKING FOR INSPIRATION

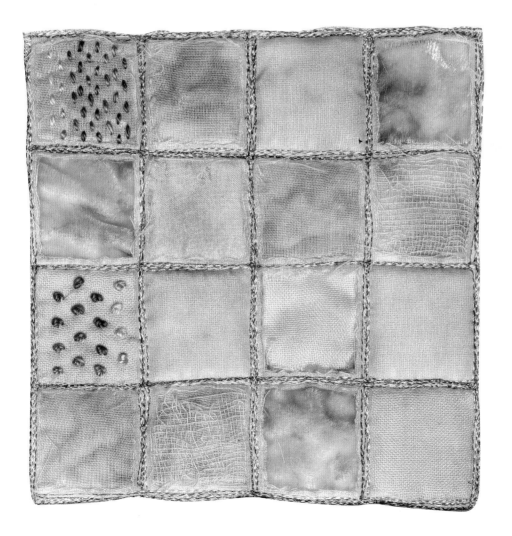

Silk paints can be applied with a sponge instead of a brush for a variegated effect. The silk paint can be used to dye cotton fabrics too, but the colour will be slightly lighter. This subtle-colour effect can be used with reverse appliqué. The layers of different fabrics are cut back to create a design and then sponge dyed to colour some of the areas. Use silk gutta to prevent the dye from seeping into parts of the design that should remain white.

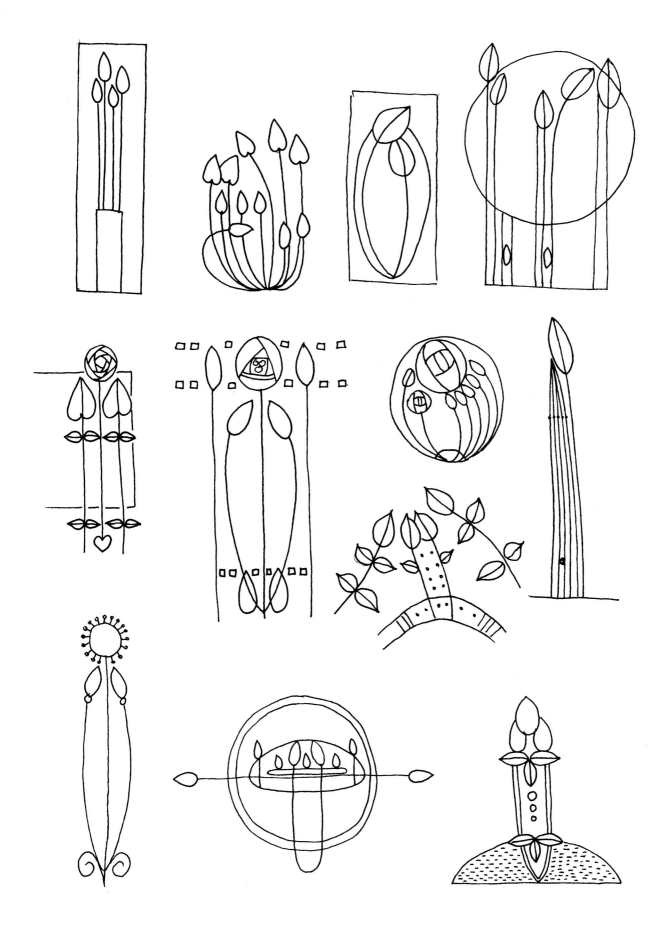

TABLE RUNNER

On one of the tables in Hill House in Helensburgh near Glasgow, there is a beautiful table runner, which was the inspiration for this project. Most of the embroidery of the period was utilitarian but that didn't mean that it was dull. Embroidery teachers such as Jessie Newbery and Ann Macbeth encouraged a strong design and bold use of colour and the resulting art embroidery was extremely attractive. Contrasting deep borders and couched threads were a feature in many designs of the period and these formed the basis of this table-runner design. The embroidery stitches used in the design are typical of the style used at the Glasgow School of Art at the end of the 19th century. The original design motif, taken from a wooden carving on the pulpit at Queen's Cross Church was simplified and adapted to suit the shape of the table runner and the technique.

The main body of the table runner is made from antique white linen with a reverse-appliqué design at either end. The appliqué fabrics were cut large enough to cover the entire appliqué area and then cut away after stitching.

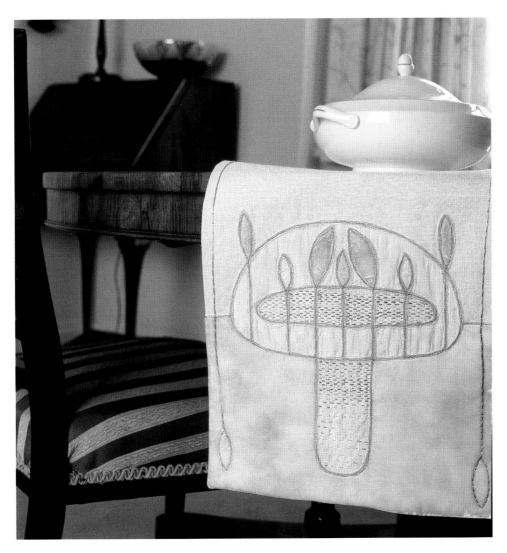

This design was adapted from an initial sketch shown in the centre of the bottom row (opposite). (Dorothy Wood.)

TABLE RUNNER

You will need

White silk/viscose velvet

White muslin

White silk organza

White Habotai silk

Antique white linen

Off-white backing fabric

Tracing paper

Silk gutta

Sponge

Silk paint colours

Threads: variegated metallic, white, variegated threads to match dyed fabric

Working the table runner

1 Cut two 30-cm (12-in) squares in each of the following white fabrics: silk/viscose velvet, muslin, silk organza and habotai silk. Cut a piece of antique white linen and off-white backing fabric, 30cm (12in) wide and as long as required for your table.

Template for table runner.

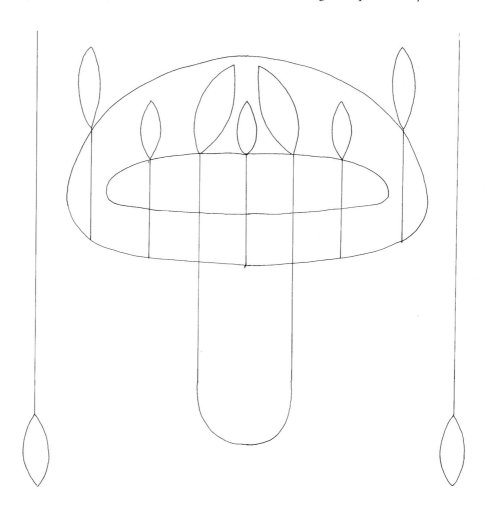

2 Enlarge the design motif until it is 23cm (9in) wide. Direct trace the design onto each square of the sheer silk organza. Layer the fabrics at each end of the linen. Begin with the silk, then the muslin, the velvet and finally the silk organza. Tack the layers down carefully.

3 Thread the machine with a variegated metallic thread and white thread in the bobbin. Set the machine for freestyle embroidery and stitch along all the design lines several times with a straight stitch.

4 Cut away all the appliquéd fabrics from above the top half of the design to reveal the linen. Cut away the silk organza from the lower half of the design motif to reveal the silk velvet. Areas inside the motif are cut back to reveal the silk and muslin fabrics.

5 Apply a line of silk gutta around the edge of the motif to prevent dye seeping onto the linen. Sponge each silk-paint colour over the entire motif to create a mottled effect. The fabrics will take the dye in different ways to create varied depths of colour.

6 Choose a variegated thread that tones in with the dyed fabric to work rows of running stitch to define certain areas. Lighter lengths of thread were selected to stitch the faded rows in the bottom area.

7 Couch a line of thread down each side of the runner 2cm ($^3/_4$ in) from the edge. End each line with a leaf shape.

8 Lay the backing fabric on top and stitch around the edge, leaving a gap for turning. Trim across the corners and turn through. Slip stitch the gap and press from the reverse side.

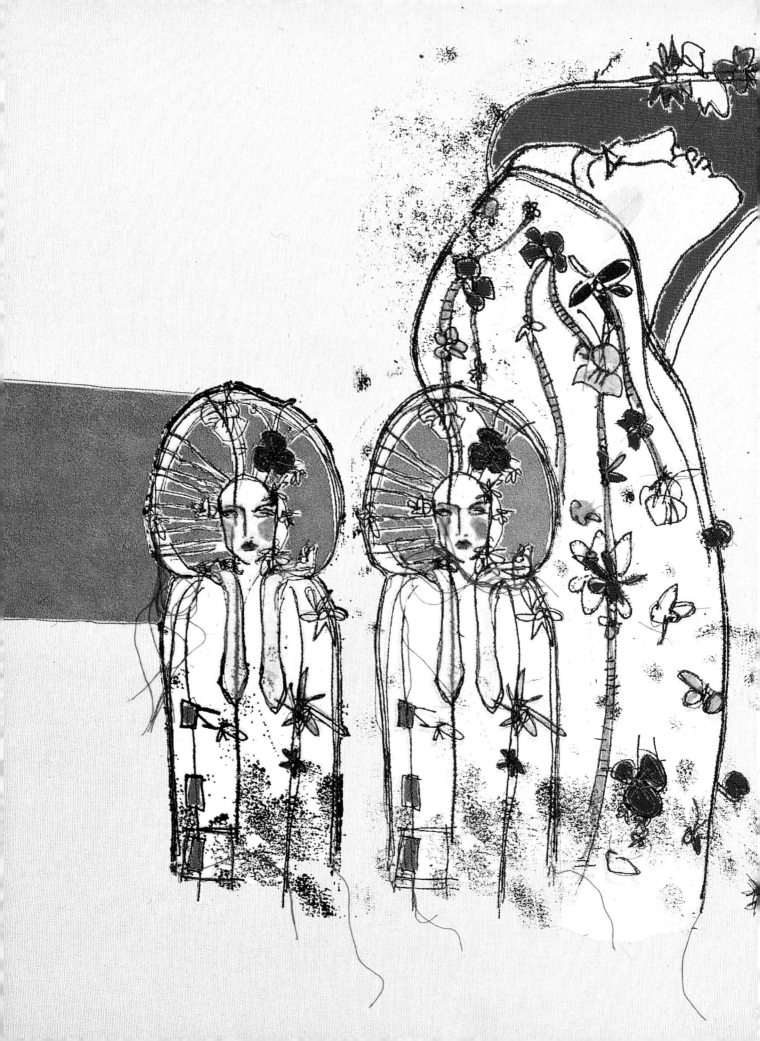

5 LINES AND LADIES

Frances and Margaret Macdonald are widely recognized as the initiators of one of the most distinctive aspects of the Glasgow Style. Their portrayal of the female persona in an elongated, conventional form was greeted with derision when first exhibited in the 1890s. The ghoulish images, described as grotesque and half-human, were considered to be a peculiar subject for young ladies in that era. The female imagery resulted in an uncompromisingly adverse reaction among critics who called the eerie malevolent designs, the 'Spook School'. Although there were female artists painting self-images at the time, these were in the Pre-Raphaelite style and the creative leap taken by the sisters, which went way beyond the existing boundaries, is now recognized as the beginning of the Glasgow Style.

Over the years, the female images created by the two sisters softened and became less controversial. Frances Macdonald's paintings moved away from the 'Spook-School' style towards the realm of fairy tales, and her beautiful, mysterious works with philosophical titles look contemporary even today. Margaret Macdonald developed a distinctive decorative style that was shown to best effect in her stunning gesso panels that were inset with shells, beads and string. The gesso panels have distinct similarities to illuminated manuscripts and certain key features such as the swooping, ribbon-like lines and elongated female forms were almost certainly inspired by Celtic art.

INSPIRED BY THE LADIES

The Glasgow Style had its heyday between 1895 and 1920 and during that time the female form was a recurring theme. Charles Rennie Mackintosh's early depictions of the female form were more conservative and rounded; wreathed in flowering tendrils, they had a gentler romantic feel, although over the years they became more elongated and stylized. His figurative paintings, however, never became as extreme as the Macdonald sisters' work.

MAKING FACES

With such a wide variety of different styles, there are plenty of images incorporating the female form to inspire the embroiderer. One of the key features of later images is the emphasis on faces. The bodies were stylized to such a degree that they became amorphous organic forms and so the face became the focal point of the images. It can be a particular challenge to embroiderers to create an attractive, realistic face in fabric. Although it might appear to be a necessity, there is no real need to be particularly good at drawing faces, as there are many techniques that can be used – the trick is to find a medium that you can work in to create the required style.

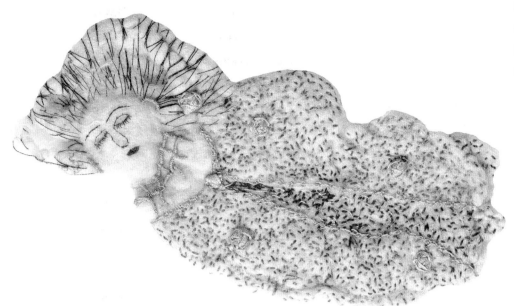

Small pieces, such as this felt lady, are an ideal way to experiment with different techniques for making faces.

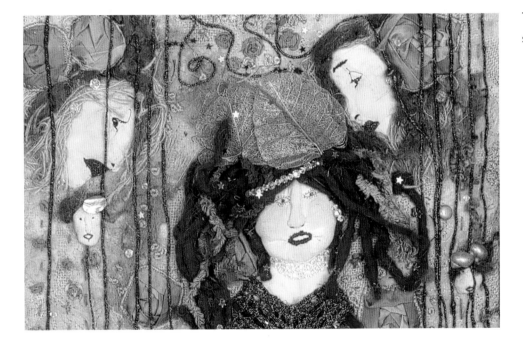

These faces are created using stockinette.

■ Sandie Maher has been inspired by Margaret Macdonald's gesso panels for many years and has tried out various techniques with an assortment of materials to create the faces. Her first faces were simply stitched by hand on cotton fabric, but these were not as attractive as she would have liked. An experiment to make a small figure in felt was more successful. This inspired her to make more three-dimensional faces and further experiments with stuffed stockinette proved to be the ideal technique for her style. A piece of stockinette is stuffed to make an oval shape of the right size. This shape is then almost invisibly stitched from the back to create the features and then embroidered by hand.

INSPIRED BY THE GESSO PANELS

Although Margaret Macdonald's gesso panels were the inspiration for this piece of embroidery by Sandie Maher, works by Charles Rennie Mackintosh, such as his beautiful watercolour 'In Fairyland' were also used as a resource. The watercolour has a central figure with long flowing lines down the length of the image, which gives it a similar feel to the finished piece. Sandie used interesting techniques, such as velvet etched with a soldering iron to create details in the embroidery. In the same style as Margaret Macdonald Mackintosh's work, shells and beads were added to the design as a finishing touch.

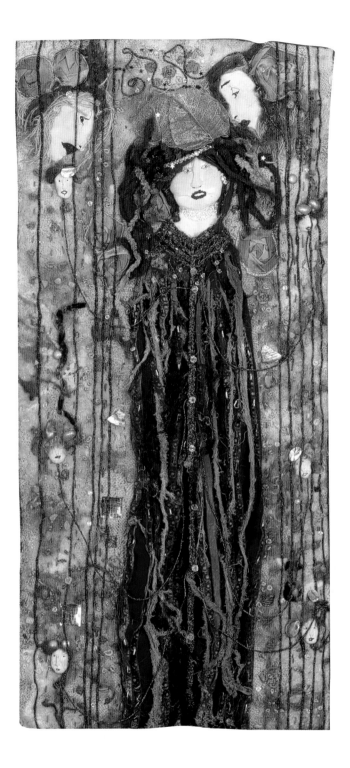

The natural hessian background was felted with wool in autumnal colours to create a woodland feel and was then stitched into using French knots and running stitch. Tiny ribbon roses were added in bright pink ribbon. The ladies' heads were cleverly made from padded stockinette and stitched to create the shape and features on the faces. Larger roses were created with overlapping dyed fabric. The central lady's dress

is covered in long lengths of textured thread and torn fabric strips. The bright-orange velvet strips are etched with a pattern using a soldering iron and are decorated with long lime-green bugle beads. To complete the design, machine-embroidered cords are draped or stitched onto the panel in vertical lines.

The frame of the embroidery was quilted and the faces painted with metallic paint to emulate the exquisite beaten metal frames that Margaret Macdonald often used for her work. She created her best work when collaborating with another designer, which in the early years was her sister, but that partnership came to an end when Frances married Herbert MacNair and moved away from Glasgow. A year later Margaret Macdonald married Charles Rennie Mackintosh and began a exceptionally creative collaboration in which each constantly inspired the other. From then on she was known as Margaret Macdonald Mackintosh and signed her designs as M.M.M.

■ 'The Opera of the Sea' painting was based on a gesso panel made several years earlier by Margaret Macdonald Mackintosh. Although it is attributed to her, Mackintosh himself undoubtedly had a hand in the design. Among his watercolour paintings is a drawing called 'Pink Tobacco Flower'. The painting was traced and reversed to create the hair of one of the figures in Margaret's 'Opera of the Sea'.

THE OPERA OF THE SEA

This luxurious tumbling mane strewn with exotic flowers was the main inspiration behind a series of contemporary embroideries by Naomi Sisson. Naomi has a distinctive style that she developed while studying at Loughborough College of Art. Instead of sketching, she works using a monoprint technique that gives a raw, immediate quality to the designs. Naomi gathered a variety of images of ladies from books on Charles Rennie Mackintosh and the Glasgow Style, including *Glasgow Girls* by Jude Burkehauser. Because this painting was completed in 1920, she also collected fashion images from the Art Deco period to give her ideas for colour and fabrics to use in the design.

Naomi Sisson finds that by drawing the same or similar faces again and again, eventually the exact shape and look that she has been working towards appears. If necessary, she copies this face to other designs to achieve the final image.

THE MONOPRINT TECHNIQUE

Naomi draws directly on paper that has been laid on an inked sheet of glass. This reverse-monoprint technique doesn't allow for rubbing out or alterations to the drawing, so the resulting image has a spontaneous, naïve feel. Naomi continues to make monoprints, allowing the design to evolve until there are several images that she wants to develop. The monoprints are photocopied and the originals put to one side. Areas of the photocopied monoprints are cut away and coloured paper or fabric inset behind to create blocks of colour. Small details are added to the front of the image to finish the designs.

WORKING ON FABRIC

Naomi selects one embellished monoprints to make the finished piece. The original monoprint is photocopied and enlarged to the required size, then transferred to a silk screen using a photo stencil emulsion. The heavy calico background fabric is prepared by applying blocks of fabric with bonding paper then the image screen printed on top. A second copy of the image is printed on brilliant white cotton. The ladies are cut out from the white cotton and appliquéd on top of the background print using bonding paper to give a subtle contrast in tone and add interest to the design. Colour is introduced in some areas using reverse appliqué and small pieces of fabric added to create details such as the flowers and faces. Finally the piece is machine embroidered with bright coloured threads to give definition to certain areas. Some of the thread ends are left to add character and texture to the finished piece.

One of the characteristics of monoprinting in this way is the light fingerprints that appear on the paper during the printing process. Far from being a defect, these add character to the design and can be used to create areas of background texture.

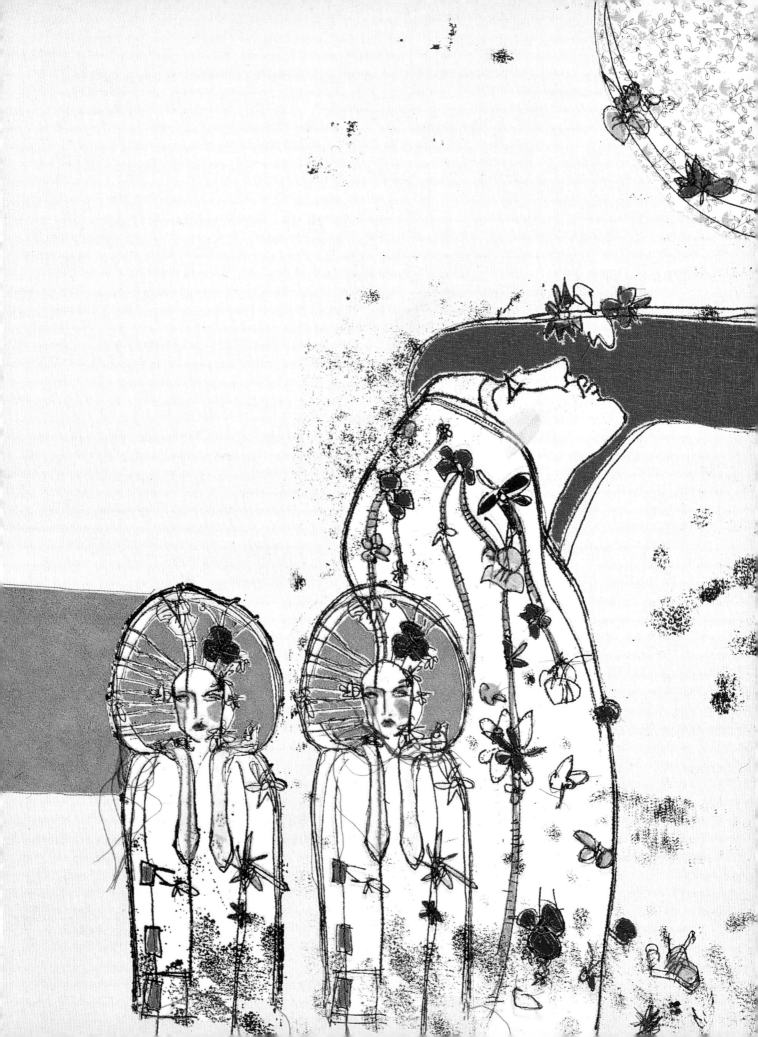

THE CELTIC REVIVAL

■ The Celtic Revival was one of several diverse art styles that emerged at the end of the 19th century and directly influenced the Glasgow Style. Much of Charles Rennie Mackintosh's symbolic work relied on Celtic imagery, and Celtic art was one of the key influences for 'The Four'. Their use of organic images, elongated ladies, swooping curves and asymmetry are just some of the design features attributed to Celtic art. Many students who were perhaps not as imaginative as Charles Rennie Mackintosh and his contemporaries worked much more closely with the Celtic style. The illuminated manuscripts in the Book of Kells and Owen Jones' Grammar of Ornament were both extensively used as a resource at the time and inspired designers to create Celtic designs in a variety of media. Many of the students worked in the Decorative Arts Studio, a room specially set up for teaching a number of craft skills including art embroidery, metalwork, woodcarving and

The original design for Margaret Gilmour's clock was simplified and adapted to create this quilted sample.

bookbinding. Students from all departments worked together and were inspired by the different design ideas and media. Many of these students carried on developing their crafts after having left college. Some set up their own studios to work and teach crafts. Margaret and Mary Gilmour were one of several pairs of sisters who worked in the Glasgow Style. Among other personal techniques, they created distinctive beaten metalwork that was characterized by jewel-like enamel insets.

USING TRANSFER FOILS

■ One of Margaret Gilmour's surviving pieces is a delightful tin wall clock decorated with interlacing Celtic lines. This intricate design was adapted and simplified to create a square-panel motif suitable for a cushion (pillow) centre or box-lid inset. The use of metallic organza and threads gives the piece a metallic look. Transfer foil was used to create the interlacing lines and the enamel insets. The fabrics were layered with thin cotton wadding and stitched in freestyle machine embroidery using a metallic thread. Italian (corded) quilting was used to emphasize the interlaced lines.

Creating the interlacing lines

The metallic quilted lines in this piece are created with transfer foil. The outside lines are on the background fabric and the inside lines on the metallic organza. Trace each set of lines separately on the bonding paper and carefully cut along the lines. Use a sharp craft knife to cut the small areas. The web is likely to fall off the backing paper as the lines are so narrow. Arrange the web carefully on the fabric and cover with baking parchment. Iron to fix and apply the foil as described in the steps above.

Transfer foil is a specialist foil on a heat-resistant plastic backing that is applied to fabric using glue and an iron. It is available in a range of colours and patterns including special hologram finishes. In this instance, bonding paper is used to stick the foil to the fabric surface. The instructions are given for the enamel insets, with further tips for creating the interlacing lines.

1 Trace the motif onto bonding paper and cut it out. Carefully place the paper with the glue web on the underside in position on the fabric.

2 Iron at a medium heat to fix and peel off the paper. Cut a piece of transfer foil slightly larger than the motif and lay it over the glue web, colour side up.

3 Iron at a medium heat. Allow to cool slightly and then peel off the plastic backing.

This Celtic design makes clever use of transfer foil to create the interlacing lines. Rather than drawing the lines on fabric, the foil was applied before stitching so that it was relatively easy to stitch accurate channels for the Italian quilting.

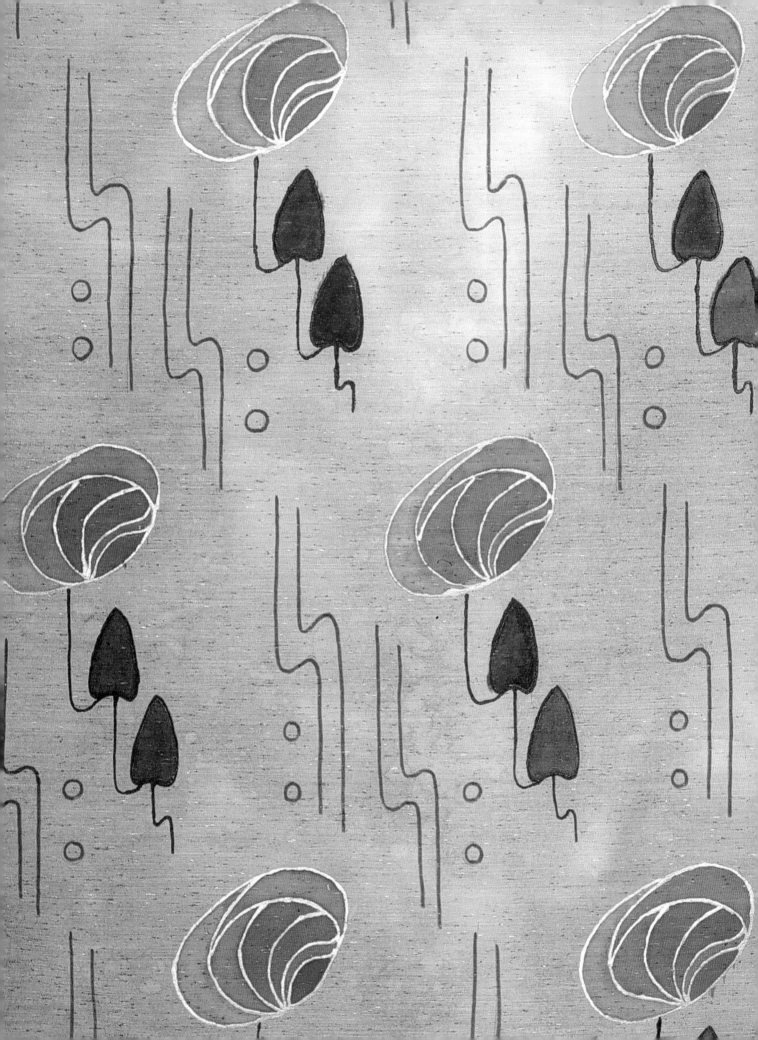

6 TEXTILE DESIGN

■ Charles Rennie Mackintosh's textile designs were created during his time in London from 1915 until he and Margaret moved to France in 1923. They moved to London from Walberswick in Suffolk where they had spent an extended recuperative holiday. During this time, Mackintosh painted a series of floral watercolours that were intended for publication in a book. It was probably the first time that Mackintosh had changed his style to suit the end purpose of the project and was a valuable experience that he then put to good use in his textile designs. He adopted a central tenet of the Arts and Crafts Movement, from which he had previously distanced himself, that saw the overall design of the artwork as secondary to its function.

Although he had used fabrics in his interiors in Glasgow, these were one-off designs for specific interiors that were handmade using stencilling, appliqué or embroidery. We know that these were often collaborative projects with Mackintosh creating the initial design and Margaret developing the idea and making the finished piece.

Shortly after moving to London, Mackintosh got his first commission for mass-produced printed textiles. The earliest designs reflect his fascination with nature and some are inspired by his flower paintings; both the watercolours from Walberswick and new paintings of cut flowers that he had been working on in London. The mass-produced textile designs are quite different from his Glasgow work – sparse linear designs were replaced by densely crowded patterns that had little empty space between the motifs.

The early textile designs have an uncertainty about them, as Mackintosh struggled to learn the idiosyncrasies of repeating patterns. He quickly realized that the delicate watercolours produced in Walberswick could not be easily adapted into repetitive patterns and began to develop designs from his much bolder cut-flower paintings. These designs were based on loose bouquets of flowers such as roses, chrysanthemums, peonies and tulips and with an interesting twist, he often used textile designs as a background for his still-life paintings.

Previous page: this delightful repeat pattern (by Beryl Smith) was created using silk gutta and silk paints.

He used repetition carelessly to enhance the vibrancy of the image, but applied his skill as a draughtsman and his instinctive use of colour to overwhelming effect, creating bold, daring, designs that were unique. Like William Morris before him, Mackintosh took to designing textiles very quickly. He was able to change subtly

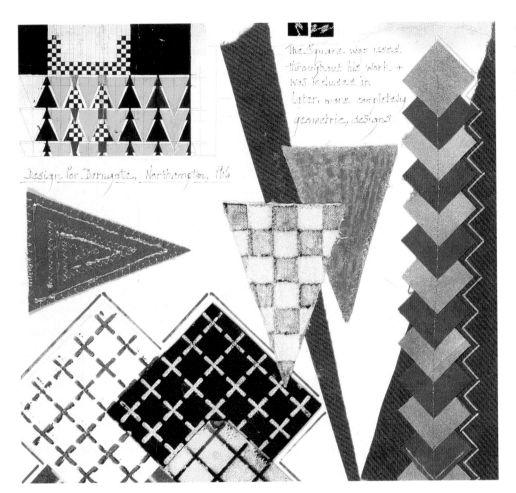

Design for Derngate, Northampton, 1916

The Square was used throughout his work + was included in later, more completely geometric, designs.

Charles Rennie Mackintosh's later textile designs used vivid colours, such as the brigh yellow/orange top left, heralding the new Jazz age

the shape or emphasis on lines of his favourite motifs to suit the new medium and his drawings show how he could change the character of the designs dramatically by altering or reversing colourways.

As the years went by, Mackintosh's textile designs became more geometric. They reflected the work that he produced for 78 Derngate, a Georgian town house in Northampton remodelled by Charles Rennie Mackintosh for W J Basset-Lowke in 1917, and the Dugout at Kate Cranston's Willow Tea Room in Glasgow. These vividly coloured designs, based on triangles, squares and diamonds, were way ahead of their time and heralded the new Jazz Age.

In all, Mackintosh created around 120 textile designs for two leading textile firms, Foxton's and Sexton's. Although none of the fabrics survive, the drawings show that he still had the same breadth of imagination and mastery of design that had characterized his earlier work.

Rennie Mackintosh textile design
'Roses and Teardrops'
1915–1923. Pencil and
watercolour.

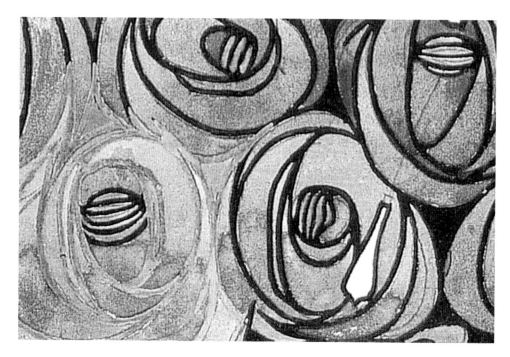

WORKING FROM THE TEXTILE DESIGNS

▪ Using Charles Rennie Mackintosh's textile designs is quite different from drawing from other aspects of his work; this is because the designs were created solely for fabric and, as such, already have a tactile quality. Most of the designs were intended to be repeat patterns suitable for long lengths of fabric, but others are individual designs that would have been used as a cushion (pillow) cover or possibly a quilt panel. None of the original fabrics exist and so it is the design rather than the finished piece that is used as inspiration. The quality of the drawings is quite different from a piece of printed fabric. Mackintosh worked on brown tracing paper so that he could trace motifs and check the repeat pattern and this affected both the quality of the painting and the colours that he used. Mackintosh would have expected the printer to even out any discrepancies in colour from one part of the design to another and also to interpret the colour as if it was on a white background.

One of Mackintosh's most famous textile designs is the Rose and Teardrop. This is perhaps because it is one of only a few that have been printed as fabric in recent years and it is also marketed as a card design and wrapping paper. The rose was one of Mackintosh's favourite motifs and it recurs throughout his work in a variety of media. This textile design is one of his most elaborate renditions of the rose motif with each of the twenty roses in the repeat quite individual. This was a favourite ploy for Mackintosh, where motifs appear to look the same but on close inspection have subtle differences.

Michelle Foster has used the Rose and Teardrop design as inspiration for a pair of cushion (pillow) panels. She chose stencilling, one of Mackintosh's earlier techniques, to create the background of the design. Michelle tried out different shapes and sizes of roses and eventually settled on a series of simplified motifs for stencilling. She experimented with cut paper and spray dye to create the background and found that lifting the stencil as she sprayed created an attractive soft edge. Several different stencils were cut and the design was stencilled on calico using two colours of Pébéo setacolour aerosol spray, fuchsia and cardinal red. Pieces of sheer fabric in various shades of pink, red and yellow were arranged on some of the stencilled roses and then the whole piece was machine embroidered. The lines of embroidery in pink, red and yellow echo the linear style in the original design. For her second panel, Michelle covered the stencilled calico in a piece of beige organza and made the roses slightly larger so that there was less empty space between the motifs.

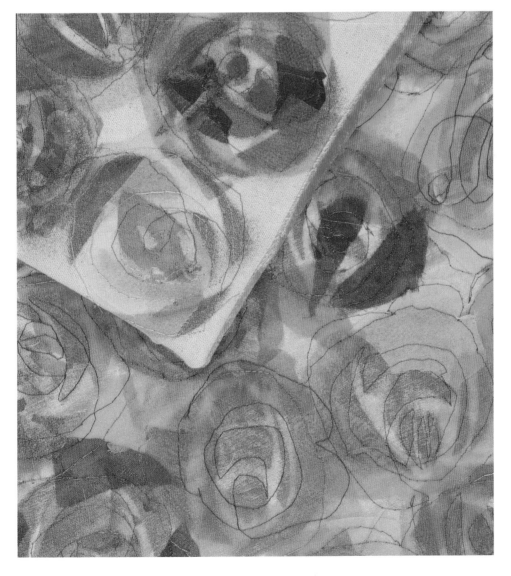

This pair of cushion panels by Michelle Foster were created following experiments with stencilling and cut paper.

SIMPLIFYING AND ABSTRACTING THE TEXTILE DESIGNS

■ If you are used to working neatly on a small scale, it can be a liberating exercise to work boldly on a larger scale to broaden your ideas and the parameters of your designs. Because Mackintosh's own graphic style is precise and neat, it can be inspiring to move away from drawing with a pencil, for example, and try painting or working with chalk pastels instead. By using a large paintbrush and acrylic paint, you are forced to change scale dramatically and develop a much freer style. Instead of tracing or carefully copying motifs, simply look at the textile design and paint the shapes that you see on a large scale. You may feel that your designs have similarities to the style of a child's painting but it is this naïvety that will give any resulting embroidery such a unique character.

Using a large paint brush and big pieces of paper creates a much simpler and freer style and instantly abstracts a design.

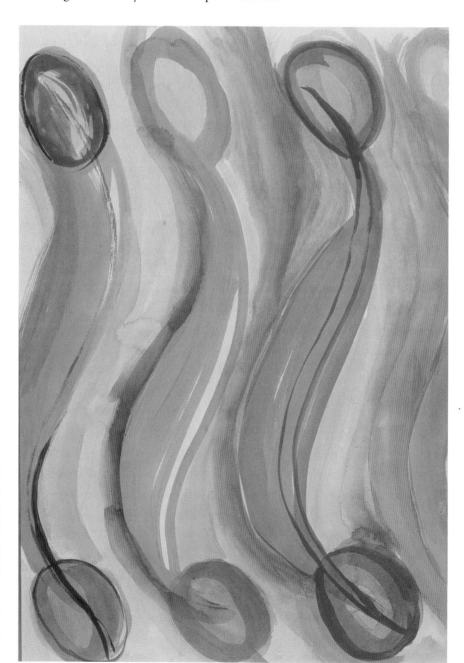

Below: Rennie Mackintosh textile design 'Stylized tulips' 1915–23. Pencil and watercolour on brown tracing paper.

Imogen Aust has used this technique to develop a series of images from Mackintosh's textile designs. Her approach to design is inspired much more by the perspective of an artist than of an embroiderer, as there is no attempt at this early stage to imagine the design in fabric. Using a large paintbrush, Imogen began simply by painting several of the designs in the original colourways to get a feel for the shapes and motifs. Imogen tried out alternative colourways and began to focus on certain elements in the design. As a result, the designs became much simpler and the motifs even more abstract.

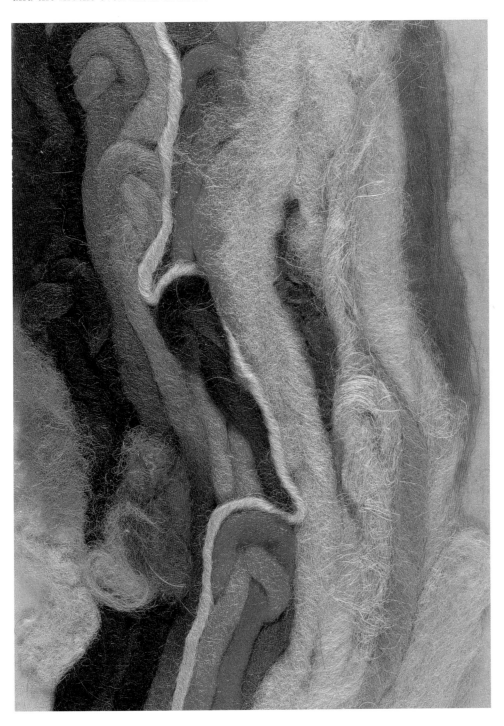

Lengths of wool were dyed, knotted and layered to resemble the tulip textile designs (Beryl Smith).

At this stage, Imogen decided that handmade felt might be the ideal fabric to capture the loose style of the paintings. She tried out several samples, such as felting motifs onto a sheer background fabric and 'painting' wool tops onto a felt background, which gave her an idea of the possibilities and constraints of the technique. Using this knowledge, she began to concentrate on the composition of the painting, balancing motifs with broad bands of colour until she created her final design.

Working with felt is not an exact technique and it is difficult to create precise graphic details. Carded wool can be laid onto the background and carefully sandwiched but as the actual felting process is quite aggressive, shapes move and the wool can shrink in different ways. What the finished felted piece will look like is unpredictable, but shapes and outlines can be corrected and details added with hand or machine stitching.

Small pieces of handmade felt were laid out on a sheer background fabric and felted together to make a new fabric (Imogen Aust).

Imogen Aust simplified her bold acrylic
paintings even further to create this bold
graphic image from Mackintosh's tulip textile
designs. The finished piece was made from
handmade felt and stitched by hand using a
variety of threads.

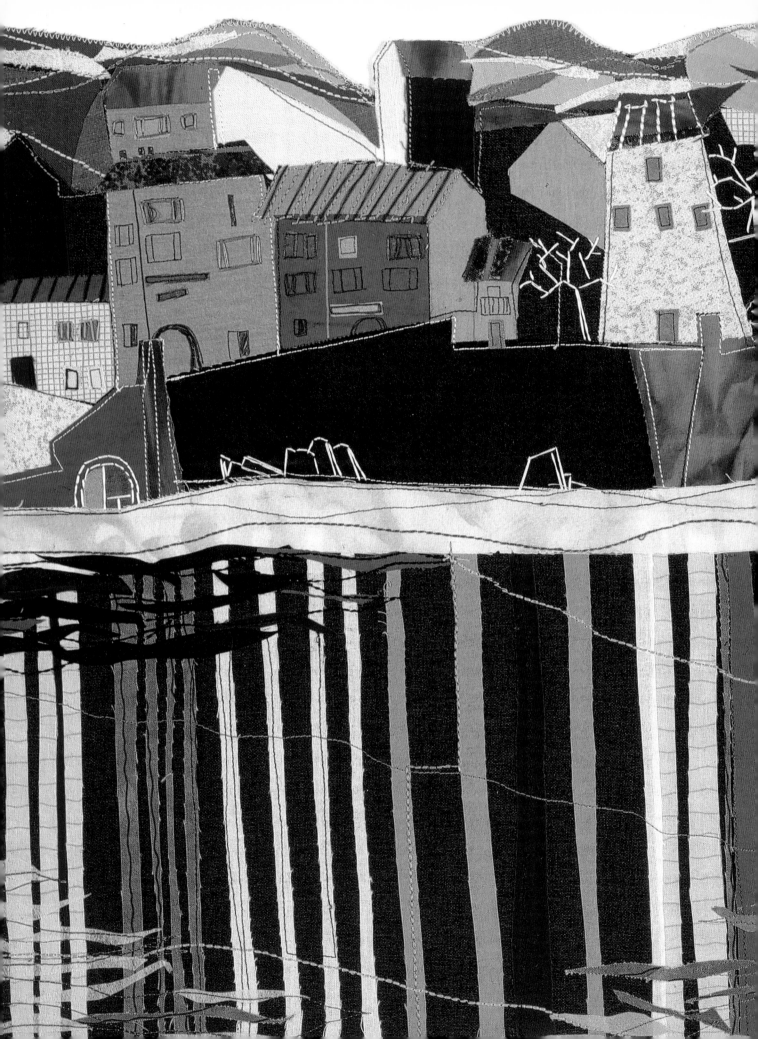

7

WATER COLOURS

■ Mackintosh was an extremely talented and determined individual who excelled in just about every medium that he tried. Best known for his architecture and interiors centred mainly in and around Glasgow, his skill as a painter was not fully developed until he left the city in his later years.

Although he sketched as a young man, he only began to introduce colour to his drawings once he was at art school. Because he liked to draw and paint outdoors, watercolour was an obvious choice. His first paintings were completed during a tour of Italy. The beautiful drawings of Italian buildings were brought to life with colour. These first paintings, exact representations of the architectural style of the buildings, were intended as resource material, but show his emerging skill as a watercolourist. Indeed one of the paintings won first prize in an art competition at the Glasgow School of Art.

Within a year, Charles Rennie Mackintosh had moved on and was painting fascinating, imaginative pictures full of symbolism and mysticism. The style later softened to a gentler imagery featuring fairies and then into the familiar elongated and stylized ladies swathed in tendrils of flowers and petals that were the inspiration for several gesso panels such as 'The Wassail'.

Michelle Foster made several watercolour paintings before trying out ideas with silk, paint, simple appliqué and machine embroidery.

Throughout his life, Mackintosh continued to sketch flowers on holiday and built up a huge design source of organic images showing seedpods, petals and gracefully arching flower stems. His style was simple, with an image drawn in pencil, select areas colour washed and details then picked out in solid colour. He didn't rub out mistakes, but preferred to incorporate them into the design.

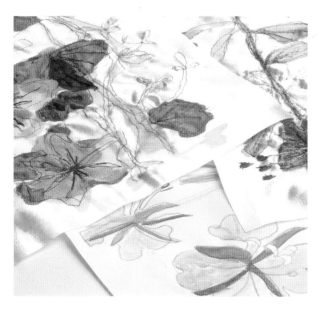

During his sojourn in Walberswick in Suffolk, Mackintosh completed more than 30 flower paintings. They were planned to be published in Germany but the war then intervened. These exquisite paintings are more stylized and finished than his previous sketches and indicate a new sophistication and maturity in his work. Each one is carefully signed, dated and labelled in a special little box.

The translucent paint and delicate sketched lines on these beautiful, ethereal flower paintings lend

themselves to a variety of different embroidery styles. The flowers could be appliquéd with layers of sheer fabric, or stencilled. Michelle Foster has chosen to replicate Mackintosh's watercolour technique by applying silk paint directly onto the background fabric. She sketched ideas from several of his flower paintings before settling on 'The Willow Herb', painted in 1919, as her main inspiration.

Working on an oyster-pink satin, Michelle used Pébéo silk paints in raspberry, Hermes red, primary yellow, green bronze, and cinnamon and Pébéo oriental red setacolour. She blended the colours and also added water to let the colour spread slightly. Working from her sketches, Michelle created the areas of colours for the flowers and stems.

She backed the painted satin with cotton wadding and calico and tacked the layers securely together ready for stitching. The flower centres were heavily machine stitched. To re-create the sketched pencil lines, Michelle drew on the satin with a vanishing embroidery pen and then stitched along the lines before they faded. Highlights in the flower centres were stitched by hand in simple running stitch and accent beads were then added to complete the design.

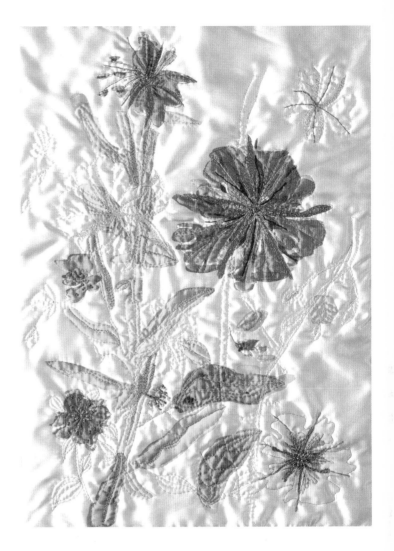

Painting with silk paints without using gutta results in a much freer 'painterly' style as shown here (Michelle Foster).

▓ In 1915 Charles Rennie Mackintosh and his wife Margaret moved to Chelsea, London. Mackintosh's artistic clothes and Scottish accent had attracted undue attention in the quiet backwater of Walberswick. With the advent of war, he aroused suspicion with his continued contact with friends and colleagues in Europe and, along with other members of the artistic community, was forced to leave. Although he continued to paint flowers, Mackintosh changed to using cut rather than wild flowers as his subject matter. In response to an increased demand from the art-buying public for paintings to hang in the home, Mackintosh painted elegant still lifes of flowers such as roses, tulips, peonies and irises and these

LONDON
AND BEYOND

established him as an accomplished watercolourist. At this time he was also designing mass-produced printed textiles and these appear in the background of some of the flower paintings. The flower paintings are colourful and assertive and illustrate Mackintosh's continuing deep respect for nature.

INSPIRED TO STITCH

■ The cut-flower paintings, showing simple bunches of flowers in an assortment of vases against a variety of backgrounds, are a wonderful source of inspiration for the embroiderer. The way that Mackintosh painted, producing realistic images with a very stylized technique, has created a resource full of intriguingly textured areas and beautiful two-dimensional flowers that are positively pleading for creative interpretation on fabric. There is a great deal for the embroiderer to learn by studying Mackintosh's use of colour, pattern and texture to create beautiful paintings. The background for 'Begonias' is actually one of Mackintosh's early textile-print designs. The design in rich burgundies and purples is shown quite faintly against the almost-black background. A similar effect could be created using batik or discharge cotton. The striped vase in the painting is also fascinating – it looks like pieces of couched ribbon on a mottled background and could be the source material for a series of embroidery samples. And, of course, the flowers themselves are stunning: full-blown begonias in white, apricot and red with a single leaf stand out beautifully against the dark background. Even just this one painting contains a vast array of possibilities for experimenting with colour and design in embroidery.

PORTE VENDRES

■ Mackintosh had turned to painting because of difficulties he was encountering in his architectural career and he finally turned his full attention to painting when he left London for the south of France in 1923. He began to perfect his technique, showing the same single-mindedness and attention to detail that he had used in his early days. Of the 46 paintings that were created during this last phase of his life, half of them were of the seaside town of Port Vendres, where the houses tumble down the steep coastline to the sea. One of the most dramatic of the Port Vendres series is 'La Rue du Soleil' where the reflections of the village and the sunlight are caught in the ripples of the sea. Mackintosh didn't attempt to capture movement in his paintings and so the beautiful reflections became dazzling abstract patterns that have great potential for interpretation in embroidery. He was fascinated by the simple shapes of the houses, which appear to be piled one on top of another and create an interesting pattern against the hillside. Mackintosh painted atmospheric and evocative landscapes that were a perfect

expression of decorative form and line. They are caused in some part by the lack of new building during the war years. In May 1927 Mackintosh wrote 'I find that each of my drawings has something but none of them has everything.' A few days later he finished his watercolour 'Le Fort Maillert', which had a special relevance to both Margaret Macdonald and himself. They referred to the building in the painting as 'our fort' because it looked like the castle of Holy Island in which they had spent their honeymoon and many subsequent holidays. Mackintosh was fascinated by the accidental structures created by nature and used his architect's eye to draw in a unique style, which makes them particularly suitable for interpretation in embroidery.

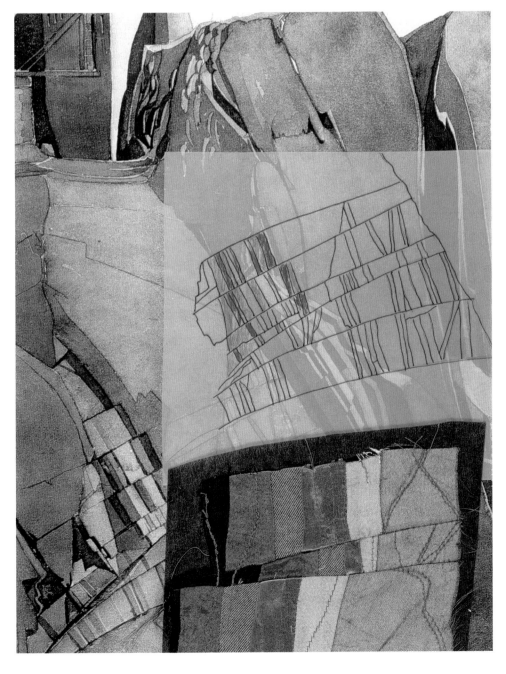

This detail from Le Fort Maillert shows the interesting shapes created by nature that so fascinated Mackintosh. Beryl Smith has traced the pattern and used it as inspiration for simple patchwork samples.

MOVING INTO
FABRIC

■ Sophie Wilks is a talented embroiderer who, like Mackintosh, focuses on architecture. She is fascinated by the relationship between buildings and their surroundings. Sophie found the Port Vendres series of paintings exciting because Mackintosh's colour scheme and style were sympathetic to her own. She was particularly inspired by the stark contrast between the figurative details on the buildings in the top half of the picture and the abstract ripples in the harbour.

Sophie used collage to create the initial design. She collected papers in appropriate colours, finding magazine pages particularly useful, as there are a wide variety of colours and patterned areas to add texture. Beginning with a black background, she identified shapes and colours in the painting and began to create the collage. Rather than taking a tracing or copy of the picture, Sophie just judged with her eye the proportions of areas in the design and in this way began to create the design in her own style.

Working on black paper adds an interesting dimension and changes the mood of the collage.

Once she was happy with the collage design, Sophie made fabric samples to try out different techniques that might be suitable for particular areas and gathered together the fabrics that she needed to complete the design. The embroidery has four distinct areas: the hills in the far background, the houses, the beach and the water. Sophie began with the hills; using four shades of green fabric she cut shapes, attached them with bonding paper and machine-stitched details in straight and stretch stitch.

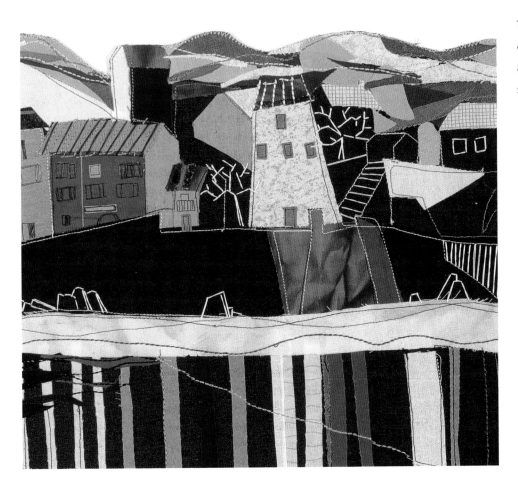

This detail from Sophie Wilk's embroidery (shown in full on page 82) shows the layered appliqué shapes and stitched details.

The shapes of the buildings were drawn on bonding paper and then cut out. Sophie used landmarks and other buildings as a guide to the size, shape and positioning of the different pieces. She added machine stitching to define the shapes of the buildings and roofs and hand-stitched details such as windows, shutters and doors to create a quirky feel.

The colours within the water reflections were chosen carefully to co-ordinate with the colours in the top half of the picture. The stripes were bonded onto the background fabric. In some cases the fabric stripes used the same colour as the object being reflected and in others a slightly darker shade. Lines of machine embroidery created a feeling of movement in the water and broke up the rigidity of the stripes. The ripples were cut and applied as before and the final stitching in metallic thread added a little sparkle to the water.

The last section to be completed was the beach. The beach fabric covered the ends of the stripes and was highlighted with machine embroidery. Hand embroidery was used to add final details to the piece.

8 MATERIALS AND EQUIPMENT

■ The materials and equipment used for embroidery in the 21st century are not tall that different from those used at the end of the 19th century, although there is, of course, a much greater choice available today. This chapter introduces fabrics, threads, dyes and equipment you might use for hand and machine embroidery inspired by the Glasgow Style.

NATURAL AND MAN-MADE FIBRES

■ In keeping with the spirit of the Glasgow School of Art, the fabrics used throughout this book are primarily made from natural or man-made fibres. As there is such a wide range of fabrics available – from the finest organdie to heavy velvet and corduroy – the possibilities are endless. Unlike synthetic fibres, which are made from chemicals, man-made fibres are made from reconstituted cellulose, which is a natural product. The first man-made fabric was rayon, appearing in 1892 after research was undertaken to find an alternative to silk; it has since been further refined and is still made today.

In many respects, in embroidery it is the fabric that is important rather than the fibre. The texture or appearance of the fabric is generally the first concern and the fibre it is made of a secondary consideration. With so many new fibres being developed every year, it is becoming more and more difficult to pick out natural or man-made fibres. This is not a problem unless you are planning to use dye or some sort of fabric paint to colour the fabric. Some dyes and paints are specially formulated for silk, whereas others work best with cotton or linen. Transfer paints and crayons only work well on synthetic fabrics, although these fabrics are difficult to dye, so it is necessary at times to know what fibre your fabric is made from.

FABRICS FOR EMBROIDERY

■ In the late 19th century, the fabrics available for embroidery were not as plentiful as today. Before the introduction of art embroidery, the most common fabrics for embroidery were linen or silk. Jessie Newbery introduced a wide range of less-expensive materials in her classes at the Glasgow School of Art because she believed that embroidery should be accessible to everyone and not just the moneyed classes. Cotton fabrics such as calico and velvet were popular, because much of the embroidery then had a utilitarian purpose.

Nowadays there is a huge range of fabrics available for all sorts of embroidery. As well as traditional fabrics such as calico, denim or velvet, there are many alternative materials that can be used, such as plastic, interfacing and paper. There is no need to buy new fabrics for every project; to keep costs down you can easily recycle

clothes and other fabric items. Alternatively, you can buy large quantities of white fabric and dye or paint it to get the required effect. Styles in embroidery change from year to year with certain fabrics becoming more or less fashionable. If you only require small quantities, specialist embroidery suppliers now have a range of exciting fabrics in 'fat quarters' that are ideal for experimenting and making small projects (fat quarter is a patchwork fabric term, meaning a half width of half a yard equivalent to a quarter yard, approximately 18 x 21in). Look out also for cheap fabrics at fabric stalls, your local market or the various stitching shows that take place throughout the year.

Listed below are some of the most commonly used embroidery fabrics. While such a wide choice can be inspiring, remember that it is just as valid to focus on individual fabrics and to research and develop specific techniques around them for natural fibres, such as making devoré from velvet or using discharge cotton.

Buy fabrics in white or neutral shades and dye to suit your particular embroidery. The materials here, from the top down: jersey, velvet, organdie, organza and metallic organza.

Muslin

A soft, sheer, slightly open-weave fabric that is usually off-white. You can buy richly dyed muslin from Asian fabric stores. In the USA muslin is the term for a lightweight calico used in patchwork. Butter muslin or cheesecloth has a looser weave. Both fabrics take dye very well.

Calico

This is a common name for a group of plain-woven fabrics that are heavier than muslin. Generally cream or bleached (white), calico is available in a range of weights. It is inexpensive and ideal for backing embroidery.

Scrim

A lightweight, loosely woven fabric that can be made from linen, jute or cotton. Originally used as an interfacing or to strengthen plaster, it is ideal for pulled work by hand or machine or to add texture to embroidery.

Hessian

Sometimes known as burlap, this heavy plain-woven fabric is generally used for backing upholstery and rugs or making sacks. It has a characteristic colour and smell associated with the jute fibres. Handmade felt can be woven into hessian to create interesting textures.

The fabrics here, from the top down: muslin, calico, scrim, hessian, evenweave linen and twill.

Evenweave linen

Available in a range of colours and counts, this is suitable for counted-thread techniques such as drawn thread work. It is also ideal for making table linen or other household items for embroidery.

Twill

This white fabric, named after its obvious diagonal weave, has a smoother reverse side that provides a firm base for machine embroidery. It is slightly lighter in weight than the similarly woven fabrics denim (in shades of blue) and ticking (generally with stripes).

Jersey

This knitted fabric is constructed in a tube shape in stockinette stitch. It is useful for making padded shapes in stumpwork embroidery. A coarser version is sold as kitchen cloths. Fine jersey curls up when cut to create interesting textural effects.

Velvet

Silk/viscose velvet is a gorgeous fabric that is very easy to dye. It can be textured using Fibre Etch, a liquid that burns away the pile, leaving the sheer background. Cotton velvet is a much heavier fabric and is available in a range of colours.

Organdie

This slightly sheer, stiff fabric is treated with sulphuric acid to produce the characteristic crisp finish. It is stiff enough to be stitched in freestyle machine embroidery without a hoop.

Organza

A light, diaphanous sheer fabric with a crisp and shiny feel. It is often used as the top fabric for reverse appliqué or for multiple layering. Two-tone organza has different colours for the warp and weft. Metallic organza has a metallic thread running in one direction only.

Tulle

Silk tulle has a delightfully soft feel and is traditionally used for bridal veils. It doesn't fray and can be used to add texture in embroidery. Nylon net looks similar but has a coarser appearance, is extremely stiff and doesn't accept dye.

Felt

Commercial felt is generally made from synthetic fibres. Make your own felt by applying heat, moisture and pressure to merino or lamb's wool. Interesting effects are achieved by felting onto other fabrics or adding threads during the felting process.

Wadding

Cotton wadding is a loosely felted fabric that is easy to quilt by hand as it is much thinner than polyester wadding. Use it to make a fabric sandwich for working freestyle machine embroidery without a hoop.

Look out for unusual natural fibres to add interesting textures to your embroidery. The fabrics here, from the top down: tulle, metallic organza, felt, cotton wadding and polyester wadding.

DYES AND PAINTS

■ Charles Rennie Mackintosh's style is instantly recognizable, not only because of the motifs and design elements that he used, but also because of his distinctive colour palette. His colour schemes developed and changed over the years, and so we have come to associate certain colours with particular motifs. In the early part of his career, Mackintosh used quite vibrant greens and blues in his paintings. In the middle years, the colours softened and he began to work with a range of tertiary colours that were thought to be progressive and daring. This palette of soft green, rose, grey blue and mauve is what most people associate with the Glasgow Style. Later, as his style became more geometric, Mackintosh introduced much bolder primary colours.

Cold-water dyes

These are fabric reactive dyes that require a fixative to set the dye into the fabric. They work particularly well on silk or viscose with slightly paler shades on cotton. Once mixed in solution, the dye can be kept for long periods but it is only workable for a few hours once the fixative is added.

Dylon dyes, sold in little tins, provide a small quantity of loose powder that is best suited to dyeing in a larger dye bath, as it is difficult to measure. These dyes are fixed with a sachet of fixative.

Procion 'M' Dyes are sold in powder form in larger tubs from batik suppliers. By mixing the dyes into a solution you can mix smaller quantities in a bag to create variegated fabrics. The dyes are fixed with a soda and salt solution.

ARTY's One colours is a range of concentrated fabric reactive dyes sold in liquid form. They are extremely easy to use and can be diluted or mixed to create a huge range of colours. Supplied with a liquid fixative, they are especially recommended for spraying techniques on silk/viscose velvet.

Fabric paints

These dyes are fixed by ironing. The paints can be stencilled, sponged, stamped and painted to create a variety of effects. They are available in standard colours as well as frosted, fluorescent and metallic ranges. Fabric paints can be diluted, inter-mixed and thickened for screen printing or monoprinting. Mixing them with white creates pastel shades.

Silk paints

These dyes are designed for use with silk fabrics. They spread easily, especially when diluted or applied to damp fabric, but can be thickened with a special anti-spread solution. Rock or table salt can be sprinkled onto the wet dye to create unusual effects. Silk gutta, available in a range of colours as well as clear, white, black and metallic, is used to outline a design motif. The paint is then brushed between the lines to create the design. Iron the fabric on the reverse side to fix.

Dyes and fabric paints are becoming increasingly easy to use. Liquid dyes are particularly simple to measure for small quantitites of fabric and can be mixed to create any colour you require.

THREADS FOR EMBROIDERY

▨ The range of threads available today is huge compared to those that were available at the end of the 19th century. Students at the Glasgow School of Art started by using crewel wool and silk floss for their embroideries, which were initially influenced by the designs of William Morris. When Jessie Newbery introduced her style of art embroidery, students began to use simpler stitches and started to embellish their embroideries with beads and ribbons.

There are many specialist embroidery thread companies that sell a wide range of unusual yarns for embroidery. Some are listed in the suppliers list (see page 125) or look out for their stalls at stitching shows around the country.

Heavier-weight threads can be used to add texture and boldness to an embroidery.

Hand-embroidery threads

It is a good idea to build up a collection of different threads in a particular colour scheme before you embark on an embroidery project. This will encourage you to try different techniques and stitches and as a result your work will become more experimental and adventurous. Stranded cotton (floss) is the standard thread for embroidery and has the advantage of being sold everywhere in a wide range of colours, but it can be surprising what other threads are available at your local needlecraft shop if you stop to look. Stranded rayon threads, for example, are much glossier than stranded cotton and available in brighter, more vibrant colours.

Single-strand threads include perlé, coton à broder, flower thread, soft cotton and crewel or tapestry wool. These are all suitable for embroidery and whether couched or stitched will produce a wonderful range of textures and finishes in your work.

You can space-dye your own threads or buy variegated threads with subtle colour effects.

Metallic threads add a touch of sparkle to your embroidery. Some are only suitable for couching as the yarn frays when stitched through fabric. Choose machine-embroidery threads or cross-stitch metallic threads for embroidery stitches.

Metallic threads are now available in a range of colours, textures and thicknesses.

Specialist threads such as cords, braids, chainette and bouclé yarns are ideal for creating heavier stitches and textures. These are sold in solid and variegated colours, but are also available in white for dyeing at home.

There are all sorts of ribbons suitable for embroidery. Ribbons can be sheer, metallic, satin, ribbed or wired and are available in a huge range of colours, patterns and widths. Try weaving, couching or slotting the ribbons through the background fabric to create interesting textures. Specialist silk-embroidery ribbons are softer and easy to stitch. Knitted ribbons can be dyed to suit. Choose viscose for vibrant, glossy colours and cotton for a paler matt finish.

Specialist ribbon for embroidery is much softer and easier to stitch with as it doesn't have a firm edge.

Machine-embroidery threads

You can use ordinary sewing thread for machine embroidery, but you will get a much better effect with threads that are designed for the purpose . These threads are weaker than an ordinary sewing thread as they are less tightly spun, but this allows the thread to flatten and blend with the background fabric mo0 re easily. Machine-embroidery threads are also finer and so create a better finish in closely packed stitching. You can use ordinary sewing thread in the bobbin, but inexpensive bobbin threads are available in a range of neutral colours. As these are finer, they match the machine-embroidery thread weight and there is also less build-up of thread on the reverse side.

Machine-embroidery threads are available in a range of fibres, such as silk, rayon, polyester and cotton as well as metallic finishes. Cotton threads have a matt finish whereas silk and rayon are shiny. They are all designed for stitching by machine but you may have to buy needles with larger eyes to accommodate the metallic threads to prevent them fraying.

Machine embroidery threads are finer than normal sewing threads so that the stitching covers an area well without becoming too dense or bulky.

EQUIPMENT

▦ Most people have a basic sewing set that is an ideal starting point for embroidery, but it is worth thinking about what items you might need to make it easier for you to stitch different yarns and try new techniques.

Needles

Embroidery needles have a larger eye than general sewing needles to accommodate the heavier threads. Use a needle that is large enough to allow the thread to pass through the background fabric without making too large a hole.

Scissors

Use dressmaker's shears to cut large pieces of fabric, medium scissors for trimming and a small pair of embroidery scissors for snipping threads.

Bodkin

Use this to pull cord or ribbon through casings. It can also be used for Trapunto quilting to pull wool through the stitched channels.

Embroidery hoop

There are two styles of embroidery hoop – wood and plastic with sprung metal. The wood version is ideal for hand embroidery but can also be used upside-down for machine embroidery as long as it fits under the darning foot. Wrap the inner ring with thin cotton tape so that it grips the fabric more securely. Machine-embroidery hoops have a sprung-metal ring that fits in a groove on the inside of the plastic hoop. Avoid cheaper, poor-quality hoops as they do not hold the fabric securely enough.

Buying good quality tools and accessories makes machine embroidery much easier. Equipment below: embroidery hoop, embroidery scissors, darning foot, bodkin and machine needles.

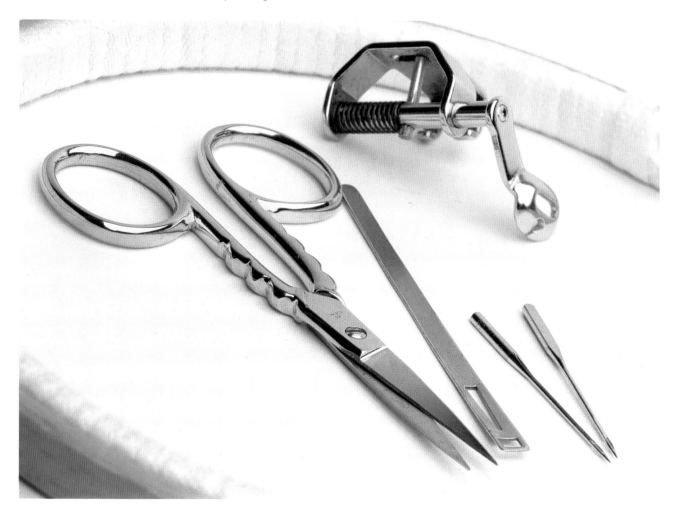

Dressmaker's wheel and carbon paper

Use these to transfer simple designs to fabric. Choose a carbon colour close to the colour of the fabric.

Fusible bonding web

This glue mesh on a silicone backing paper is generally used for appliqué but can also be painted and ironed onto fabric or thread to create unusual effects.

Water-soluble fabric

There are various types of water-soluble fabrics that disappear when immersed in water. They are generally used to create lacy fabrics or motifs in machine embroidery. Use the heavyweight variety to make stiff, freestanding stitched pieces and sticky-back water-soluble fabric to hold fabrics and threads in position for stitching. (See pages 47–49.)

Machine needles

Use embroidery, metallic or top-stitch needles that have larger eyes for machine embroidery. For normal stitching, a size 70 (9) or 80 (12) needle is adequate, but for freestyle stitching change to size 90 (14) or even 100 (16) to prevent the needle breaking.

Spring needle

This needle has a spring mechanism that allows you to work a freestyle machine embroidery without a hoop or darning foot. You can change the needle inside the spring if it breaks.

Darning foot

This is used for freestyle machine embroidery; it moves down to push the fabric against the needleplate momentarily so that the stitch can form and then lifts up to allow free movement. Always lower the feed teeth on the machine when the darning foot is used and lower the presser-foot lever before beginning to stitch.

Cording foot

This has a groove or hole to guide the thread, cord or ribbon through when couching by machine. Some are large enough to guide cord for making machine-embroidered cords.

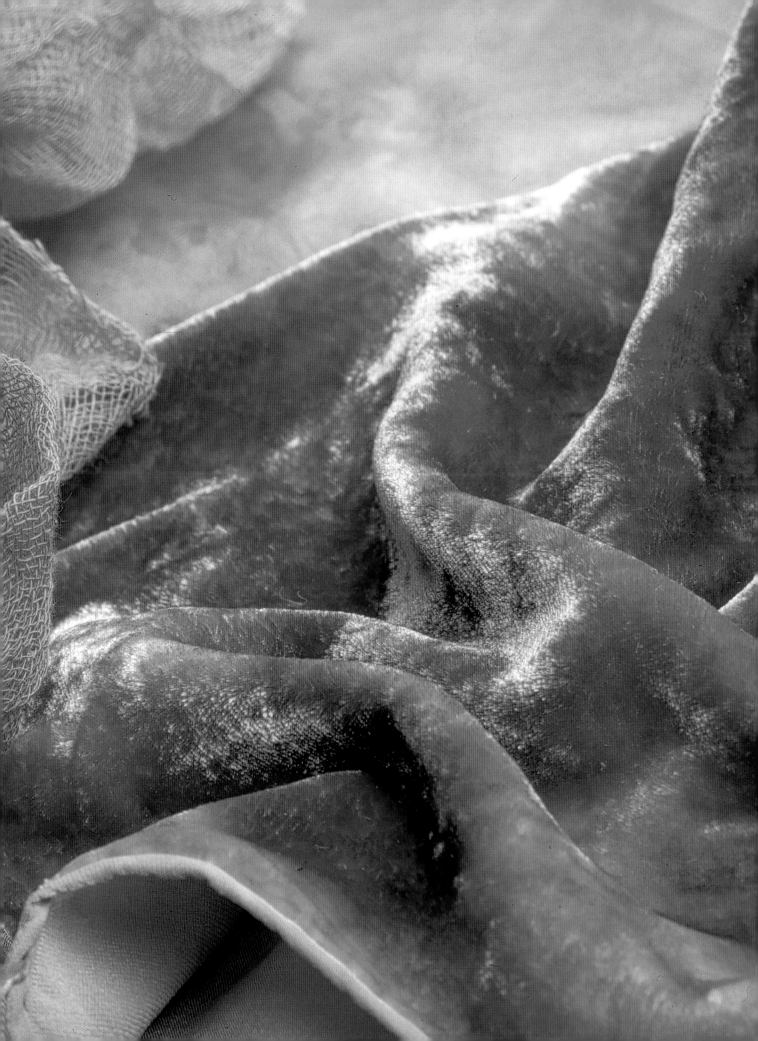

9 TECHNIQUES

This chapter covers some of the basic techniques used for embriodery today. It is an ideal introduction to those new to embroidery, with guidelines for transferring designs onto fabric and instructions for basic embroidery stitches used at the Glasgow School of Art c. 1895. More experienced embroiderers may find the new dyeing techniques and machine embroidery of interest.

DYEING THREAD AND FABRICS

If you spend much of your time looking for particular colours of fabric, now may be the time to try your hand at dyeing. As there is no need to dye huge quantities of fabric for embroidery, a polythene bag can replace the traditional dye bath. This method of dyeing is clean and easy and takes up a minimum of room. You can buy tubs of cold-water dye from specialist suppliers and six basic colours (lemon, chrome yellow, cerise, scarlet, cobalt blue and turquoise) will let you mix almost any colour you require. If you would like to start by experimenting with the technique in a small way, use small tins of Dylon dye. The dyes need a fixative so that the dye bonds with the fabric, but once it is added the dye solution will only keep for about 12 hours. The dye itself is mixed with water and can be stored for a long time. With the fixative and dyes ready mixed in solution, dyeing is quick and easy with no mess. You will need a plastic bottle for each dye colour and one for the fixative.

Preparing the dyes

Cold-water dye requires a fixative so that the dye remains in the fabric and doesn't wash out. The fixative is a combination of table salt and household washing soda mixed in the proportion of three measures of salt to one of soda. Mix 6 tablespoons of salt and 2 tablespoons of soda and add just enough water to dissolve them. Then pour into a bottle ready for use. Mix 1–2 teaspoons of dye powder with a little hot water and top up to 600 ml (1 pint) with cold water. Pour each mixed dye into a labelled bottle ready for use. Store the solution in a cool place.

Variegated dyeing in a bag

This method of dyeing can be used for single colours, but wonderful effects can be achieved using two or three dyes at one time. Cotton, viscose and silk are all suitable for cold-water dyeing. Silk and viscose can be added dry, but you will need to dampen cotton before dyeing it.

Cut a small quantity of fabrics and threads that will fit loosely in a small clear plastic sandwich bag. Pour in a small quantity of dye solution over the fabrics.

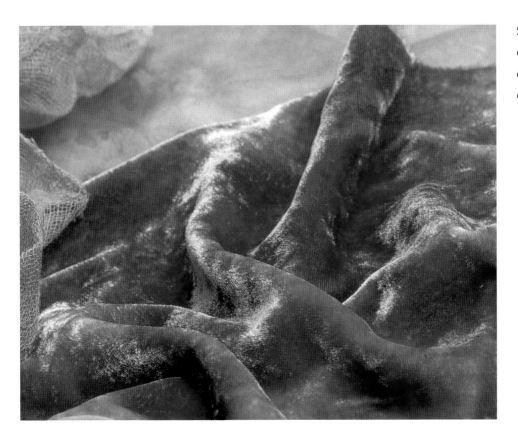

Silk/viscose velvet takes dye extremely well and small quantities can be dyed using the 'variegated dyeing in a bag' method.

Repeat with a second colour and then add a little fixative. You will need approximately 25 per cent fixative to 75 per cent dye solution. Squeeze the fabric through the clear plastic sandwich bag to distribute the dye. Use just enough dye to soak in: if there is too much the loose dye will pool in the bottom of the bag and turn all the fabric the same colour. Seal the top of the bag and leave to one side for an hour.

Rinse the fabrics and threads in hot water with a couple of drops of detergent and then rinse in cold water until the water is clear. Hang up to dry. Experiment with small quantities of fabric and different combinations of the dyes. Keep notes and fabric swatches together so that you can repeat the colourway at a later date.

Using a dye bath

Fabrics take dye in different ways, so that even if you dye using the same colour, the fabrics will all turn out to have slightly different shades. Black dyes, for example, will give a range of greys through to black. You will need about 2 tablespoons of dye powder in 600ml (1 pint) of water for each 250g (8oz) of fabric. Half fill a bucket with water. Weigh the fabric and add sufficient dye solution to the dye bath. Stir in 150ml ($^1/_4$ pint) of prepared salt/soda solution and

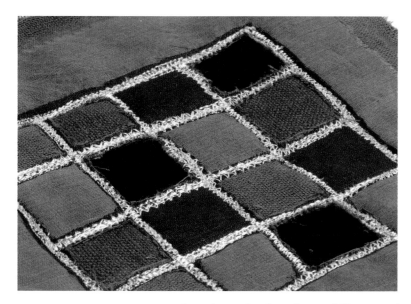

Black dye was used to dye a range of different natural fabrics in the same dye bath. The resulting fabrics were used to make this reverse appliqué sample.

add the dampened fabric. Stir for the first 15 minutes and then stir from time to time for the next hour. Rinse the fabric in hot water with a few drops of detergent and then rinse in cold water until it runs clear.

Spraying

Another easy way to dye fabric is by spraying. You can buy pre-filled dye sprays or a pump-action spray bottle that is designed for dyeing. ARTY's One dyes have been developed especially to use in sprays. The concentrated dye is already in liquid form and the dyes can be mixed and diluted to achieve the exact colour required. This method is ideal for silk or silk/viscose velvet but can also be used for cotton or viscose. Mix the diluted dye with fixative according to the manufacturer's instructions and half fill the spray bottle. Pump to compress the air and you are ready to spray. Spraying the same area twice can increase the depth of colour. Over-spraying the surface with a second colour will create a variegated effect. Mask off areas with card or tape or use a stencil to create distinct areas of colour.

Transferring a design to fabric

When working with such a design-based source as Charles Rennie Mackintosh you need to be able to transfer a design or motif onto the fabric that you have chosen to use. The method you select will depend on the type of embroidery you are working and whether the piece will be washed.

Direct tracing is the simplest method. If the fabric is fairly translucent, you can simply lay it on top of the template and trace through. For heavier fabrics, tape the template to a window or light box: if you tape the fabric on top, you will be able to see the design. If the lines will be covered in the finished piece use a soft pencil, otherwise a vanishing embroidery pen is ideal. If you are not stitching along all marked lines in the same day, tack for a more permanent mark.

Dressmaker's carbon is available in a range of colours that can be matched to your background fabric. Choose a colour that is quite similar to the fabric but still allows you to see the design lines once transferred. The carbon paper is laid

between the template and fabric, carbon-side down. Use a dressmaker's wheel or pencil to transfer the design.

Prick and pounce is an old method of transferring designs but is still a good method if you want to avoid marks on the fabric. Put a tablespoon of cornflour in a double layer of muslin and tie to make a little bag. Prick holes along all the design lines. This can be done by hand, or with a machine with no thread in the needle. Rub sandpaper over the rough side of the paper to remove the bumps. Lay the template on the fabric and dab the pounce bag over the surface. The transfer lines can be tacked if required.

HAND EMBROIDERY

When considering stitches for use in a piece of work inspired by Charles Rennie Mackintosh or the Glasgow Style, it is a good idea to research the stitches that were used by embroiderers at the Glasgow School of Art such as Jessie Newbery, Jessie M King and Ann Macbeth. Initially embroidery was worked in crewel wools on linen, but because Jessie Newbery wanted to encourage people from all walks of life to participate in her classes, cheap fabrics such as hessian, flannel and calico became more common. She was an enthusiastic teacher and encouraged her students to develop their own design ideas, favouring a linear style that reflected her early training in stained glass, enamels and mosaic. Most embroidery, especially in the early years, was utilitarian with simple stitches chosen to suit the design and materials. Embroidery appeared on table linen, bags and cushions (pillows) and was also used on collars, belts and cuffs to create some unique personalized clothing.

Preparing to stitch

Hand embroidery can be worked on almost any fabric and in a wide variety of threads, although if the piece is designed to be worn or washed, there will be certain restrictions. There are many specialist companies supplying interestingly dyed threads and fabrics that could be used to build up a bank of stitch ideas. It is a good idea to back any fabric for embroidery with a cheap fabric such as calico or muslin, which gives the fabric body and lets you anchor threads on the reverse side with a couple of back stitches. The type of backing fabric you choose should depend on the weight of the thread, the density of stitching and the product's end use. Where possible, work hand embroidery with the fabric stretched in an embroidery hoop or frame to prevent puckering and use a needle large enough to take the thread through the fabric without fraying.

French knot

The French knot was one of the most common stitches employed at the Glasgow School of Art. It was often worked singly in a row alongside a piece of couched braid or ribbon as a design accent, or alternatively worked solidly in a circle. This little motif, made almost entirely of French knots, was very popular on its own or as a flower centre.

Right: The size of the French knot depends on the thickness of the thread and the number of times the thread is wrapped around the needle. Although not essential, the tiny stitch anchors the knot exactly where you want it.

Far right: Bring the needle and thread up through the fabric. Sew a small stitch where the thread emerges and wrap the thread around the needle two or three times. Gently pull the needle through, holding the knot in place. Stitch back through the fabric at the side of the knot.

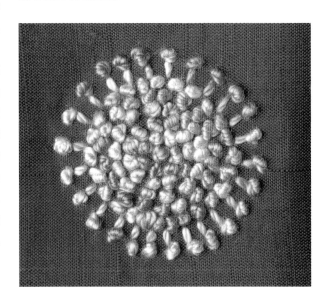
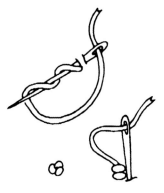

Running stitch

As embroidery became more of an art form, hems that had been worked unobtrusively were turned to the right side and stitched with bold running stitches. Running stitch was also used as a filling stitch, worked in rows rather than the more familiar seeding stitch often used today. Use a variegated thread to add interest.

Right: Running stitch is traditionally worked with the same length of space and stitch. Experiment with different lengths of stitch and space to create anything from a tiny prick stitch to a long basting stitch.

Far right: Bring the needle and thread up through the fabric. Take the needle in and out through the fabric several times, running several stitches together before pulling the needle out.

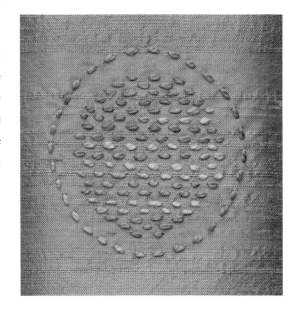

Satin stitch

Satin stitch is a good stitch for edging in traditional appliqué as it covers the raw edges and holds the fabric pieces firmly in place even in the wash. Jessie Newbery used this stitch for her simple pink-linen roses.

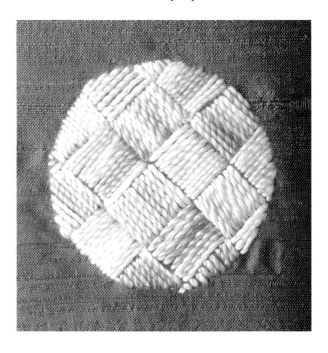

Far left: Satin stitch is a simple stitch but it takes practice to execute it neatly. It can be used to stitch thick design lines in embroidery or to fill small shapes such as leaves and hearts.

Left: Work straight stitches across the shape, keeping the threads close together so that no background fabric is visible. For a padded effect work satin stitch over a base of tiny running stitches.

Long-and-short stitch

William Morris and the Arts and Crafts Movement made this stitch popular and it was commonly used in the early years of embroidery at the Glasgow School of Art. It is well known as a stitch for creating wonderful shading on petals and leaves and is also a quick and easy way to fill areas with solid colour.

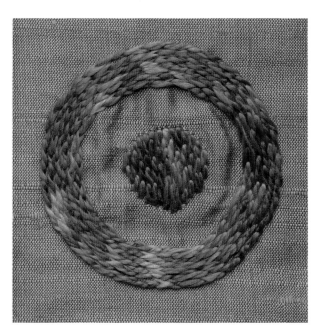

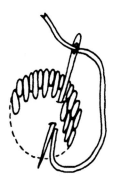

Far left: The foundation row of long-and-short stitch produces a neat edge for the outside of a shape, whereas the inner rows have an irregular appearance that allows a change of colour to blend gradually.

Left: Work the initial row in alternate long and short stitches to solidly cover the fabric. Work subsequent rows, varying the length of the stitches to create an irregular line.

Couching

Right: Couching can be worked as a long line or to fill a solid shape, either by coiling the thick thread or working rows across the shape. Use a large needle to take the bulky thread back through to the reverse side.

Far right: Pin or hold the thick thread or braid to be couched flat on the surface of the fabric. Bring another thread out next to the thick thread. Work straight stitches across the thick thread.

Couching is a simple stitch used to apply ribbons, threads and braids to fabric in embroidery. It was a technique that suited the linear design style introduced by Jessie Newbery at the Glasgow School of Art.

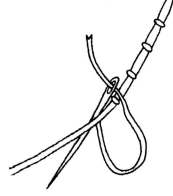

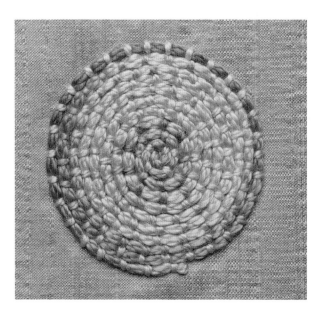

APPLIQUÉ

■ This technique is simply a method of applying pieces of solid fabric to the background fabric to create a design. It was introduced by Jessie Newbery as a way of breaking away from the painstaking dense stitchery that was popular at the time. Her aim was to create interesting embroideries with the least amount of effort. This technique became so popular that by 1901 the department at the Glasgow School of Art was known as The Department of Needlework, Embroidery and Appliqué.

In traditional appliqué, the fabric piece is tacked carefully in place and then edged with closely packed satin stitch to prevent it fraying. Nowadays, fusible bonding web makes appliqué much simpler to work.

Using bonding paper

Bonding paper has a fine web of adhesive on one side that is activated by heat. The paper is ironed onto the reverse side of the fabric and then the motif or shape cut out. Because the adhesive prevents the fabric from fraying, quite intricate shapes can be cut. The paper backing is then peeled off and the shape can be ironed in place on the background fabric.

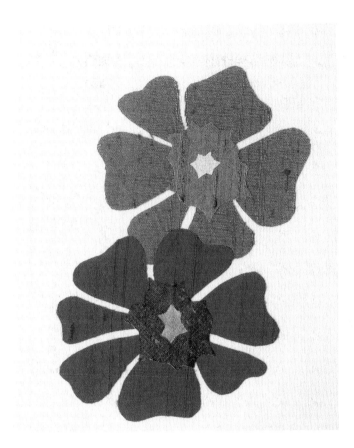

Stained-glass appliqué

This style of appliqué is appropriately named because of its similarity to stained glass. It is an effective technique to use for adapting some of Charles Rennie Mackintosh's stunning stained-glass designs. The narrow bias binding, available from all good quilting shops, has a self-adhesive backing that makes it easy to use.

The cushion made on page 54 has been made using self-adhesive bias tape. As the silk is so fine, it has been hand stitched in place rather than being attached with bond paper

Trace the design and mark the colours on each section. Trace each reversed shape onto bonding paper so that the same colour shapes are in a group. Cut each colour group out roughly and iron onto the right colour fabric. Cut out each shape 3mm ($1/8$ in) outside the lines. Peel off the backing paper and position the appliqué pieces on the background fabric. Iron to fix.

Working from the centre of the flower out, cut lengths of bias tape to fit and iron them in position. As you work outwards, the raw ends will be covered by the next piece of bias tape. The bias binding can be slip stitched down to secure if you need to use of wash it.

Turn the design over to the reverse side before transferring the shapes to bonding paper, otherwise the finished design will be transferred back to front. Leave a border of bonding paper around the traced motif before it is ironed onto the fabric. This ensures that there is adhesive right to the edge of the motif when it is cut out.

Reverse appliqué

This technique is worked in a completely different way to normal appliqué. It has similarities to quilting, as the layers of fabric are piled together to create a sandwich. Rather than cutting patches of different fabrics, any fabric or colour that you want in the design has to be layered together. Depending on the thickness of the fabrics used, you can have as many as 10 or 12 different layers. The order of the fabric layers is not crucial if the fabrics are of similar weight, but if you have a heavy fabric think about where you want it to be. A bulky fabric such as velvet could be the top layer if you are cutting away around the motif to leave interesting textured areas, otherwise put it on the bottom to give the finished piece body. When choosing which fabric to use on top, think about the colour you want to have on the design lines. As you cut away areas of fabric either side of the stitching, a thin sliver of the top fabric remains.

The design lines can be stitched by hand or machine, although the piece is more hard-wearing where close, firm stitches are used. Transfer your design to the top fabric and tack the layers together. For a secure but fine line, set the machine to stitch a narrow satin stitch. Stitch all the lines and remove any thread ends. Cut through the layers one at a time to avoid mistakes, taking care with loose woven fabrics such as muslin and cheesecloth.

This motif was taken from one of Margaret Macdonald Mackintosh's textile designs. The original top fabric has been cut away around the motif to reveal a new background fabric.

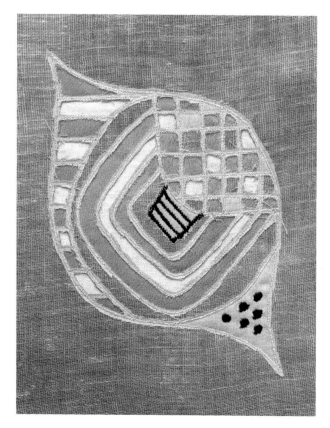

■ This is a stitching technique that adds padding between two layers of fabric. The padding can either be inserted before the piece is stitched or can be added to particular areas later. Use a combination of the different methods on one piece of work so that the padding is exactly where you want it.

There are many different types and thicknesses of wadding so you can select one that will achieve exactly the right quilting effect. Quilting shops supply a wide range of wadding suitable for quilting, from the finest cotton to the thickest polyester wadding. Polyester is the cheapest option although it can produce a rather stiff result. The 50g (2oz) wadding, which is about 7mm ($^3/_8$ in) thick, is ideal for hand quilting and stabilizing fabric for machine embroidery. Cotton wadding is much thinner and can be used to add stability to a piece of embroidery without adding much bulk. When worked by hand, a piece of quilting with cotton wadding retains its soft finish.

Creating a quilt sandwich

A quilt sandwich consists of three layers – the top fabric, the wadding and the backing fabric. The amount of relief created on the top fabric depends on the thickness of the wadding and the firmness of the backing fabric. Although you may be tempted to use a thicker wadding to get a raised quilted effect, thin wadding materials can produce subtle results that are much more attractive in embroidery. Some areas can always be padded from the reverse side at a later stage (see Trapunto and Italian quilting below).

The important thing to remember with any method of quilting is that preparation is the key to successful results. The layers must be tacked securely together before stitching to prevent tucks appearing as you stitch. Tack across the diagonal in both directions, across the centre horizontally and vertically and then round the outside edge. For machine quilting, an extra few rows of tacking will prevent the fabric layers slipping in the machine.

A quilt sandwich eliminates the need for a hoop in machine embroidery as the padding prevents the fabric from scrunching up and puckering.

Italian and Trapunto quilting

These two methods of quilting are different from ordinary quilting as the padding is added after stitching (see page 25 for an example). In Italian or corded quilting, wool is pulled down narrow-stitched channels to produce thick padded lines on the right side, whereas Trapunto quilting has larger areas stuffed from the reverse side. In embroidery these distinct methods can be worked together to create different effects and can be used to add extra padding to quilting worked on thin cotton wadding.

Right: In Trapunto quilting use a bodkin to manoeuvre the wadding into the corners of the motif.

Left: In Italian quilting, use a pair of pliers to pull the needle and wool back through the backing fabric.

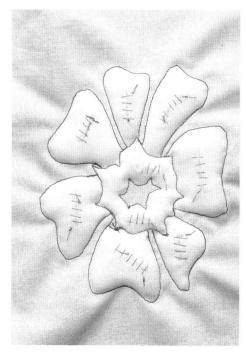

In Italian quilting as shown above, transfer the reversed design onto the backing fabric and tack the two layers together. Machine or hand stitch down all the design lines. Thread a large needle with a short length of quilting wool. Thread the needle through one of the channels from the reverse side, taking care not to go through the fabric on the right side. Push the needle along as far as it will go and then bring it back out on the reverse side. Pull the wool through, leaving a short tail. Go back through the same hole leaving a small loop on the reverse side. Work along the channels, taking smaller stitches on the curves.

In Trapunto quilting, as shown above, transfer the reversed design onto the backing fabric and tack the two layers together. Machine or hand stitch down all the design lines. Cut a slit through the backing fabric and use a bodkin to fill the area with loose stuffing. Sew the two cut edges together securely. Pad other areas in the design in the same way.

Water-soluble fabric

This fabric gives you the opportunity to create wonderful pieces of machine embroidery without a fabric backing. The first water-soluble fabric was a fine clear sheet that tore very easily, but there are now products on the market that are much easier to use. The standard water-soluble fabric available now is more like fabric and ideal for stretching in a hoop. A similar sticky-back version can also be used to introduce pieces of fabric or threads into the stitching. There is also a paper version that can be stitched without a hoop and a heavyweight clear sheet for freestanding embroideries. The extra-thick fabric leaves a residue in the machine-embroidered fabric that stiffens as it dries.

With water-soluble fabric, make sure all the shapes are linked by machine embroidery stitches otherwise the piece will fall apart when rinsed in water.

Stitching water-soluble fabric

The critical moment for a piece of stitching worked on water-soluble fabric is when it gets rinsed to remove the sticky residue. It is important to link all the stitched areas, because no matter how good it looks when complete, if the stitching is not interlinked it will fall apart when rinsed. Try out a few small samples to find out what happens to different methods of stitching when rinsed. If the stitching is to be fairly heavy, a grid pattern of criss-crossing lines can be stitched to support the stitches. On narrower bands, zigzagging will hold the threads stitched on top together. You will find that the choice of bobbin thread is crucial to the finished appearance. Although it is not obvious as you stitch, the bobbin thread is an integral and very visible part of the finished piece once it has been rinsed. Choose a colour similar to one of the top threads and keep it the same throughout.

Adding threads and fabrics

Sticky-back water-soluble fabric is ideal for adding pieces of fabric or threads into the machine stitching. As it is more expensive, use small pieces of the sticky-back fabric to arrange the thread or fabric and then stick these in position on standard water-soluble fabric. If required, several layers of different water-soluble fabrics can be stitched together to build up a design. The layers will all dissolve in water, leaving the new stitched piece.

MACHINE EMBROIDERY

■ There are two basic methods of working machine embroidery: with the presser foot in place or working in freestyle with a darning foot. Both methods can be worked on the majority of machines, because generally only straight and zigzag stitches are used.

Using the presser foot

With the presser foot in position, movement is restricted as the machine will only allow a forwards or backwards movement. It does, however, give you greater control to create accurate straight lines or soft curves. Although it is difficult to get a feeling of spontaneity, interesting textures can be created using both straight and zigzag stitches. Work a sampler sheet for future reference using a variety of threads and fabrics. Use the bobbin spool for thicker threads and work from the reverse side for a raised effect or use a cording foot to couch threads with zigzag stitch.

Right and opposite: Try out lots of designs and patterns in machine embroidery to improve your technique and build up a reference for future use.

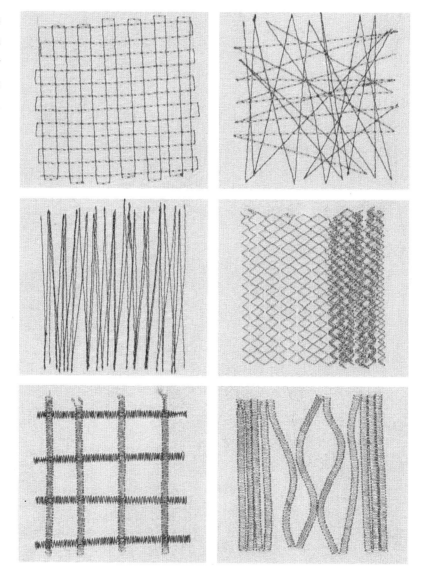

Freestyle machine embroidery

This gets its name from the freedom of movement you achieve by removing the presser foot and lowering the feed dogs on the machine. The fabric is then free to move in any direction – imagine that you are drawing on fabric, except that the fabric moves instead of the pencil.

The only difficulty with machine embroidery is that the fabric must be flat on the needleplate for the stitch to form. With practice, you can stitch with no foot at all, but most people prefer to use a darning foot. This special foot presses down on the fabric just as the stitch is formed and then rises again to allow complete freedom of movement. Unless the fabric is stiff or thick, it is also easier to machine stitch if the fabric is stretched in an embroidery hoop. This not only holds the fabric against the needleplate but also keeps it taut to prevent puckering. Alternatively, you can iron a stiffened fabric onto the reverse side or layer the top fabric with thin cotton wadding and calico. This quilt sandwich, tacked securely, is easy to stitch on and prevents puckering without adding a great deal of bulk.

Getting started

Use a size 90/14 needle with a large eye in the machine to prevent the thread fraying. Needles for metallic-thread embroidery or topstitching are ideal. Loosen

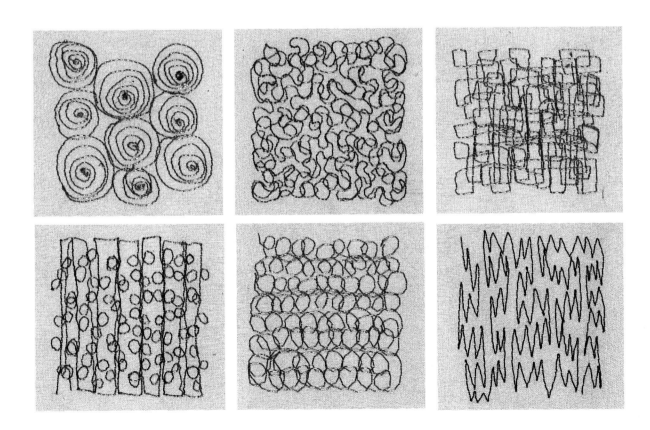

the top tension slightly and fit the darning foot. Turn the stitch length dial and stitch width to zero. Place the prepared fabric under the darning foot ready to begin. You need to lower the foot even if you are stitching without the darning foot as this engages the stitching mechanism. If you leave the foot up the stitches will not form properly. To keep the stitching neat, work a couple of stitches on the spot where you want to begin and then snip the top thread. To increase the length of the stitch you need to move the fabric further or press down on the foot pedal to increase the speed. This balance between speed and stitch length takes time to perfect.

Stitch patterns

Machine embroidery is used either to build up areas of colour or to create a textured surface. The effect that you achieve will depend on the stitch pattern that you use. Random stitching may cover the area eventually but the end result will be messy. There are various traditional freestyle patterns such as vermicelli and seed stitch that have been used for a number of years, but you could also try designing some of your own. Creating a worksheet of samples will give you practice stitching the various patterns and more control over the design. When you begin to plan a larger piece of embroidery, use the stitched samples to help choose particular patterns for areas of the design.

Detail from the machine embroidered box on page 49.

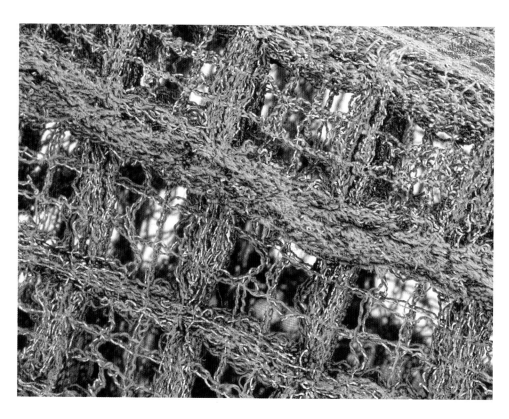

BIBLIOGRAPHY

Roger Billcliffe, *Charles Rennie Mackintosh Textile Designs*, Pomegranate Art Books 1993

Roger Billcliffe, *Mackintosh Watercolours*, John Murray 1978

Jude Burkhauser (ed) *Glasgow Girls: Women in Art and Design* 1880–1920, Canongate 1990

K E Sullivan, *The Life, Times and Work of Charles Rennie Mackintosh*, Caxton Editions 1997

Edwin Swinglehurst, *Charles Rennie Mackintosh*, Grange books 2001

Elizabeth Wilhide, *The Mackintosh Style Décor and Design*, Pavilion 1995

CHRONOLOGY

1864 Margaret Macdonald is born on 5th November in Tipton, Wolverhampton

1868 Charles Rennie Mackintosh is born to the McIntosh family on the 7th June in Glasgow

1872 The Royal School of Needlework is established

1878 The McIntosh family move to Dennistoun in the east of Glasgow where Mackintosh begins to develop his lifelong love of nature

1884 Age 16, Mackintosh is apprenticed to architect John Hutchison

Mackintosh and Herbert MacNair enrol part-time at the Glasgow School of Art

1885 Mackintosh's mother dies

Francis Newbery is appointed as principal of the Glasgow School of Art

1889 Mackintosh joins the architectural practice of Honeyman and Keppie as a junior draughtsman

Francis Newbery marries Jessie, an accomplished embroiderer and teacher

1891 Francis and Margaret Macdonald enrol at the Glasgow School of Art

Mackintosh wins the Alexander Thomson Travelling Scholarship and spends several months travelling around Italy on a sketching tour

1893 Francis Newbery introduces Mackintosh and MacNair to the two Macdonald sisters

Mackintosh changes his name from McIntosh

The progressive magazine *The Studio* is published for the first time

1894 'The Four' publish *The Magazine* to promote their work

Mackintosh's final year at the Glasgow School of Art

Jessie Newbery reorganises the embroidery classes at the Glasgow School of Art

1896 'The Four' exhibit at the London Arts and Crafts Society to hostile reviews when their work is described as from the 'Spook School'

Mackintosh draws up plans for the new Glasgow School of Art

Mackintosh designs the murals at Buchanan Street Tea Rooms, Glasgow

1897 Mackintosh designs the furniture for the Argyle Street Tea Rooms in Glasgow

Work on Queen's Cross Church in Glasgow begins

1898 Herbert MacNair's move to Liverpool signals the end of the collaboration between 'The Four'

1899 Frances Macdonald and Herbert MacNair are married

William Davidson commissions Mackintosh to design Windyhill in Kilmacolm

1900 Margaret Macdonald and Charles Rennie Mackintosh marry

Mackintosh designs the interiors for the Ingram Street Tea Rooms in Glasgow

'The Four' exhibit at the eighth Secessionist Exhibition in Vienna

1901 Mackintosh becomes a partner at Honeyman and Keppie. He enters a competition to design a 'house for an art lover'

1902 Mackintosh exhibits at the International Exhibition of Modern Decorative Art in Turin

Work begins on Hill House in Helensburgh

1903 Walter Blackie commissions Mackintosh to design Hill House

Mackintosh designs The Willow Tea Rooms in Glasgow

1904 Mackintosh designs the interiors for Holy Trinity Church in Stirling

1906 Margaret and Charles move to 78 Southpark Avenue in Glasgow

Mackintosh designs the Oak Room at Ingram Street Tea Rooms and the Dutch Kitchen at the Argyle Street Tea Rooms in Glasgow

1907 Work begins on the west wing of the Glasgow School of Art

Mackintosh travels to Portugal

1909 Mackintosh designs the interiors for Kate Cranston's home, Hous'hill in Glasgow

He also designs the interiors for the Ingram Street Tea Rooms in Glasgow

1911 Mackintosh creates the Cloister Room and the Chinese Room at the Ingram Street Tea Rooms in Glasgow

1913 Mackintosh resigns from Honeyman, Keppie and Mackintosh

1914 Margaret and Charles leave Glasgow for an extended soujourn in Walberswick in Suffolk and Mackintosh begins work on his watercolour flower paintings

1915 Margaret and Charles move to Chelsea in London and Mackintosh begins to paint still-life flower paintings

Mackintosh receives his first commission for mass-produced textile designs

1916 A series of oil paintings including 'The Opera of the Sea' are exhibited at The Royal Academy in London

1917 Mackintosh designs the Dugout at The Willow Tea Rooms in Glasgow

1918 William Davidson buys the Mackintoshs' house in Glasgow

Mackintosh designs the interiors for 78 Derngate, Northampton

1923 Margaret and Charles move to the south of France and Mackintosh begins the Port Vendres series of watercolours

1927 Due to ill health Margaret Macdonald Mackintosh returns to London

1928 Charles Rennie Mackintosh is diagnosed with cancer of the tongue and dies on 10th December

1933 Margaret Macdonald Mackintosh dies

SUPPLIERS LIST

COATS CRAFTS

Anchor and Alcazar machine
embroidery threads

Quilting wool

Kreinik and Anchor metallic threads

Anchor multicolour

Customer service line

01325 394237

GILLSEW

Fibre Etch

Silk/viscose velvet

Transfer crayons

Transfer foils

gillsew@ukonline.co.uk

01494 881886

ARTY'S

Silk/viscose velvet

Wide range of silk fabrics for dyeing

One fabric dyes

Pump sprays for dye

www.artys.co.uk

01737 245450

PÉBÉO

Setasilk silk paints

Silk gutta

Setacolour fabric paints

Tagger spray setacolour

Expandable fabric paint

www.pebeo.com

02380 701144

OLIVER TWISTS

Hand dyed threads, fabrics and fibres

Tel 0191 416 6016

JAMES HARE SILKS

A wide range of silk dupion and other
silk fabrics.

For nearest stockist or mail order call:

0113 243 1204

www.jameshatesilks.co.uk

PFAFF SEWING MACHINES

Pfaff UK

For nearest stockist call

01934 744533

INDEX

ACKNOWLEDGEMENTS

This book would not have been possible without the help of some very talented embroiderers. I would like to thank Val Beatty of Loughborough College of Art for recommending several ex-students. Graduate textile artists Naomi Sisson, Sophie Hackworth and Michelle Foster, and Coventry textile lecturer Imogen Aust were all commissioned to design pieces especially for this book. Their differing styles and approaches have added a variety and depth that would have been impossible for me to achieve on my own. My thanks to them and good wishes for continuing success in their embroidery careers.

City and Guilds tutors Janet Dowson and Gail Cowley recommended students to me and other work for the book was sourced following an open letter in the March 2003 issue of *Stitches* magazine. This led to a wide response from embroiderers all over the world who had been inspired by Charles Rennie Mackintosh and the Glasgow Style. My thanks to Kathy Troup for including the letter at such short notice.

The response was overwhelming and it was with great regret that I was unable to include work from all the talented embroiderers who contacted me. The following embroiderers, who all created their work as part of, or following a City and Guilds course in Embroidery or Patchwork and Quilting, had created pieces that were relevant to the text. My sincere thanks to Janet Adams, Beryl Smith, Ena Dean and Sandie Maher for sending me their work for inclusion in the book. I would especially like to thank Bob Brierley for sending me images of work by his late wife Judith.

I was delighted with the response from suppliers who provided much needed materials and equipment for use in the making of the projects and samples in this book. Contact details for the suppliers are listed on page 125 but thanks go to James Hare Silks, Coats Crafts, Pebeo and ARTY's for their support. Thanks also to Pfaff UK who provided a Pfaff sewing machine, which was used to make all the machine-stitched samples in the book.

Thanks also to Michael Wicks for his inspiring photography and to Tina Persaud and the other members of the editorial team at Batsford who have made such an excellent job of putting the book together.

Finally, thanks to David who gives me such support at home while I'm working on a book and to my daughter Sorrel for making such a competent job of compiling the index.